LOCOMOTIVES OF THE WESTERN UNITED STATES

Jonathan Lewis

AMBERLEY

First published 2017

Amberley Publishing
The Hill, Stroud
Gloucestershire, GL5 4EP

www.amberley-books.com

Copyright © Jonathan Lewis, 2017

The right of Jonathan Lewis to be identified as
the Author of this work has been asserted in
accordance with the Copyrights, Designs and
Patents Act 1988.

ISBN 978 1 4456 6910 6 (print)
ISBN 978 1 4456 6911 3 (ebook)

British Library Cataloguing in Publication Data.
A catalogue record for this book is available from
the British Library.

Origination by Amberley Publishing.
Printed in the UK.

Introduction

The railroads of the Western United States are now mainly owned and operated by the BNSF and Union Pacific. In recent decades both railroads have expanded through acquisitions and mergers to become the giant corporate railroads of today.

The Burlington Northern Santa Fe, now known as BNSF, was formed in 1996 with the merger of the Burlington Northern and the Atchison Topeka & Santa Fe (known as the 'Santa Fe') railroads. The Burlington Northern was itself a result of a 1970 merger between the Chicago Burlington and Quincy (the 'Burlington'), Northern Pacific, Great Northern and Spokane Portland and Seattle railroads. Today BNSF has around 32,500 miles of track with over 8,000 locomotives.

The Union Pacific was originally formed in 1862 to build the first transcontinental railroad – known as the 'Overland Route' – jointly with the Central Pacific (that later became part of the Southern Pacific), which was completed in 1869. This is still one of the principal transcontinental freight routes. The Union Pacific began its recent corporate expansion in 1982 with the acquisition of the Missouri Pacific and Western Pacific railroads. This was followed in 1988 with the acquisition of the Missouri Kansas Texas railroad and in 1995 with the Chicago North Western. In 1996 the Union Pacific acquired the Southern Pacific, which itself had merged in 1992 with the Denver & Rio Grande Western Railroad (the 'Rio Grande'). Today the Union Pacific has around 32,100 miles of track and over 8,000 locomotives.

In addition to BNSF and the Union Pacific there are many shortline and regional railroads serving local regions and industries, interchanging with the major railroads. In the Eastern USA and Canada there is a similar structure and their locomotives can often be seen in the Western USA.

There are a number of principal transcontinental routes in the Western USA. The most northerly is the former Great Northern route now part of the BNSF, which crosses the Rocky Mountains over Marias Pass in northern Montana. South of this route is the former Northern Pacific route which was leased by Burlington Northern to a regional railroad called Montana Rail Link in 1987. This route is also used as an overflow route for BNSF as well as running its own trains.

The Overland Route across southern Wyoming is the Union Pacific's principal transcontinental route splitting three ways in western Wyoming and Utah to serve the Pacific North West, central California and southern California. South of this, across Colorado is the former Denver & Rio Grande Western route from Denver to Salt Lake City. However since the Union Pacific takeover most through traffic has been rerouted on the Overland Route.

BNSF's former Santa Fe route across northern New Mexico and Arizona is the busiest transcontinental mainline with as many as eighty trains a day in some places. This route carries mainly intermodal traffic to southern California.

North of the Mexican border is the former Southern Pacific Sunset Route from New Orleans to Los Angeles. This has recently been upgraded by the Union Pacific and now handles some Chicago to Los Angeles business from the Overland Route.

In addition to the east–west lines there are several north–south routes that result in a network linking all major cities in the Western USA together.

The exploitation of western coal reserves since the mid-1970s has led to unprecedented growth in traffic in parts of the west. In eastern Wyoming a new 120-mile-long line was built to serve the Powder River Basin coal mines. To meet the traffic demand, parts of this route are now four tracks. Almost half of all American coal now comes from the region with both big railroads having access.

Historically the railroads ran their own passenger services on their own tracks. However, passenger numbers declined with the construction of the Interstate Highway System and introduction of jet aircraft on internal flights. The railroads were making substantial losses and started to withdraw services. In 1971 the Federal Government created Amtrak to provide a limited long distance passenger network running on the tracks of the freight railroads.

Diesel locomotives had replaced most steam locomotives by the end of the 1950s. Diesel locomotives are today built by two manufacturers, Electro Motive Diesel (EMD) and General Electric (GE). EMD was a subsidiary of General Motors since the 1930s. It is now owned by Caterpillar but still uses General Motors-designed diesel engines and transmissions.

All locomotives have standard control systems, which allow them all to work in multiple with only one crew in the lead loco. This has allowed trains to increase in length and are regularly over 120 cars long, weighing over 15,000 tons.

Distributed Power Unit (DPU) technology has allowed locomotives to be distributed throughout the train controlled by radio from the lead locomotive. This has eliminated the use of helper locomotives with a full crew on most mountain passes, but the practice is still in use in a few places.

Locomotive technology is continually being developed to meet railway and environmental demands. Locomotives with AC traction motors were introduced in the late 1980s in response to increasing weights of coal trains but can now be seen on all types of traffic. Both EMD and GE produce their locomotives with a choice of DC and AC traction motors. Environmental concerns regarding diesel emissions have led to the development of Tier 4 compliant locomotives by both manufacturers.

The photographs in this book feature trains with a wide selection of different locomotives and paint schemes from across the Western States. The captions aim to identify the main points of interest in each picture and the location so that it can be found on a detailed map.

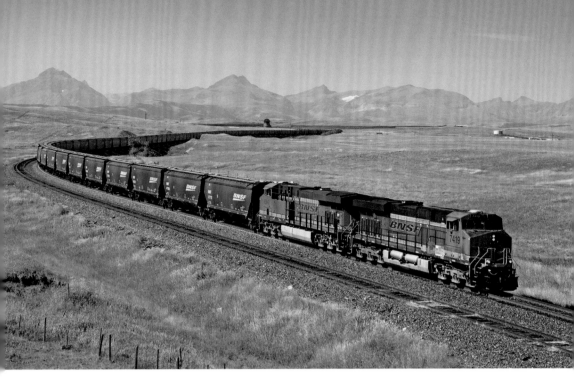

Starting with a typical vista of the west with the Rocky Mountains in the distance, which the train just crossed via Marias Pass, BNSF ES44DC 7419, built by GE in 2008, is seen leading an eastbound grain train near Browning, Montana, on 15 September 2013.

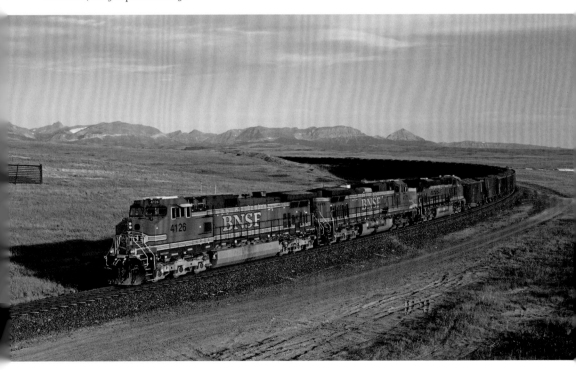

Rounding the curve west of Browning, Montana, BNSF C44-9W 4126, built by GE in 2002, is seen leading an eastbound ballast train with the mountains of Glacier National Park forming a backdrop on 15 July 2015.

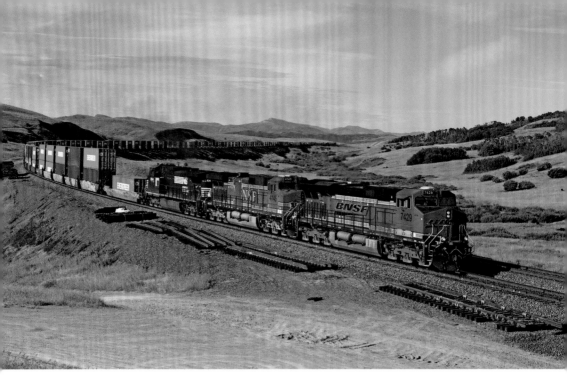

An eastbound double stack train is seen being led by BNSF ES44DC 7429, built by GE in 2008, with C44-9W 4145 and a Norfolk Southern C40-9W at Spotted Robe, Montana, on 15 July 2015.

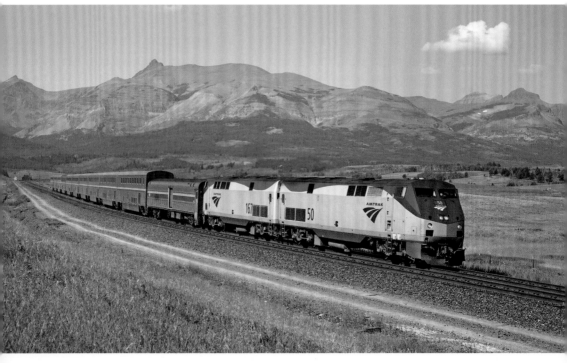

Amtrak P42 50 and 167, built by GE in 1997 and 2001 respectively, are seen leading Amtrak's Seattle–Chicago 'Empire Builder' passenger train away from the station stop at East Glacier on the east side of Glacier National Park on 1 September 2009.

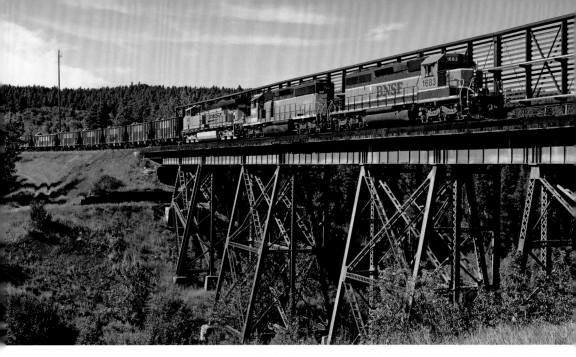

The once-common SD40-2s are now restricted to local traffic on most railroads, so it is rare to get them leading on a line where there is no industry to serve. On 15 July 2015, BNSF SD40-2s 1683, built by EMD in 1973, and 1947, built in 1979 (both for the BN), with a more modern ES44AC 5993 are seen working a ballast train from Marias Pass Summit into East Glacier. The fence behind the train on the bridge is a wind break to stop containers being blown from trains.

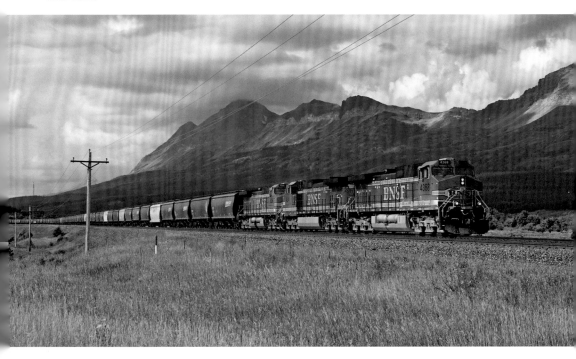

With a stormy sky over the mountains BNSF C44-9W 4368, built by GE in 1999, is seen leading an eastbound empty grain train with two more classmates at Bison descending Marias Pass between Summit and East Glacier on 14 September 2013.

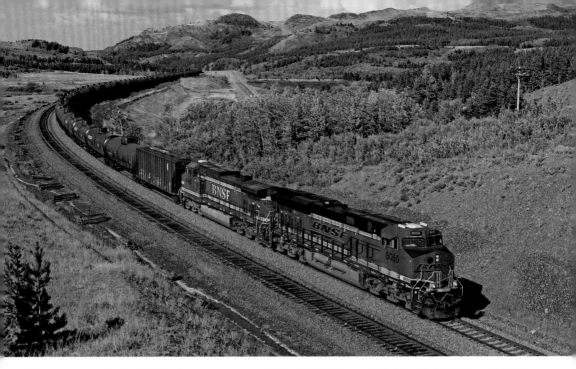

In recent years unit oil trains have become a common sight on BNSF due to the Bakken Shale Oil Boom in North Dakota. On 13 July 2015, BNSF ES44C4 8050, built by GE in 2014, is seen leading a westbound unit oil train at Bison climbing Marias Pass.

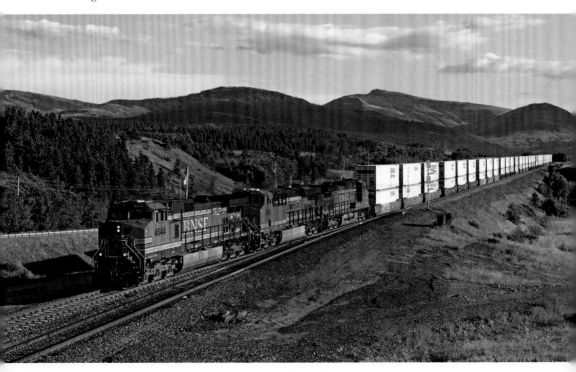

BNSF run four high-priority intermodal trains (known as Z trains) each way per 24 hours between Chicago and the Pacific North West – two go to Seattle and two go to Portland. On 14 July 2015, BNSF C44-9W 4644, built by GE in 2000, is seen leading an eastbound Z train to Chicago at Bison, descending Marias Pass.

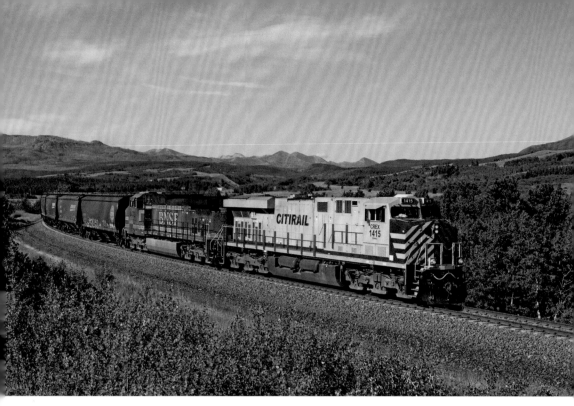

Citirail-owned ES44AC 1415, built by GE in 2015, on long-term lease to BNSF is seen leading an eastbound empty grain train descending Marias Pass between Summit and Bison on 15 July 2015.

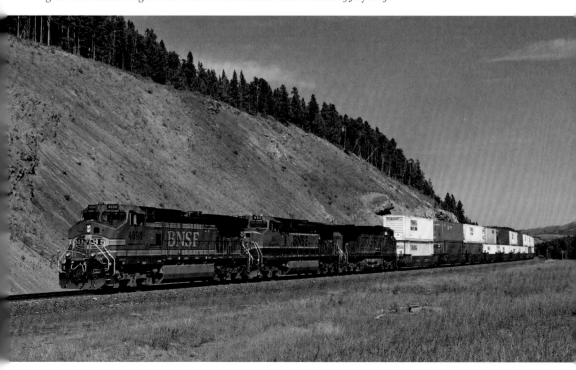

BNSF C44-9W 4698, built by GE in 2000, is seen leading a westbound Z train from Chicago to the Pacific North West, nearing the summit of Marias Pass at an elevation of 5,213 feet on 15 September 2013.

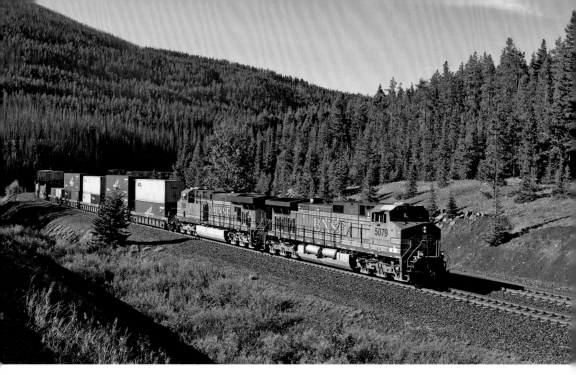

The west side of Marias Pass is the steeper side of the pass with a grade of 2.2 per cent (1 in 45). Most trains on this side of the pass have helpers added to the rear at Essex for the trip to the summit. On 15 September 2013, BNSF C44-9W 5079, built by GE in 2004, is seen leading an eastbound stack train just below the summit of Marias Pass.

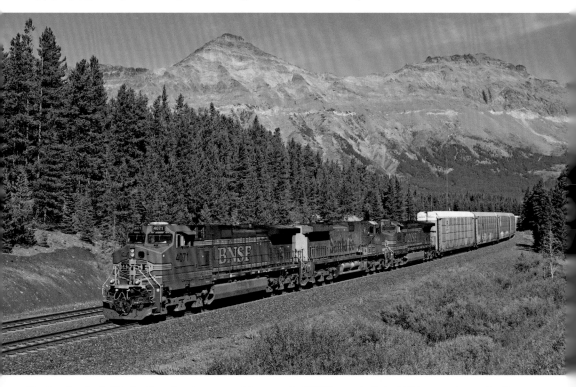

Passing the classic Marias Pass view just west of the summit, BNSF 4071, built by GE in 2003, is seen leading a westbound autorack train, starting the steep descent to Essex on 15 September 2013.

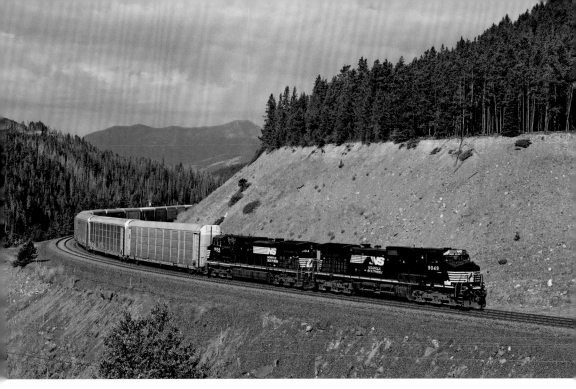

Norfolk Southern C40-9W 9049 and 9104, built by GE in 1997 and working for BNSF, are seen leading an eastbound autorack train climbing up to Marias Pass Summit on 13 July 2015.

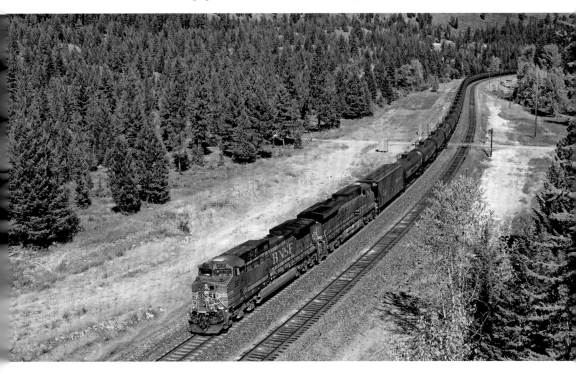

BNSF AC4400CW 5619, built by GE in 2003, is seen leading a westbound unit ethanol train at Fisher River between Whitefish and Libby, Montana, on 6 September 2013. This section of line was relocated in the 1960s when the Libby Dam was built, flooding the original route.

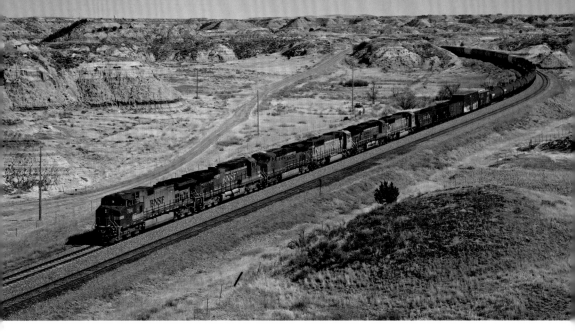

On part of the former Northern Pacific route still owned by BNSF, BNSF C44-9W 784, built by GE in 1997 and delivered in the Santa Fe-inspired Warbonnet livery with five other locos, are seen leading a westbound manifest passing through the Dakota Badlands, passing Sully Springs just east of Medora, North Dakota, on 31 March 2012.

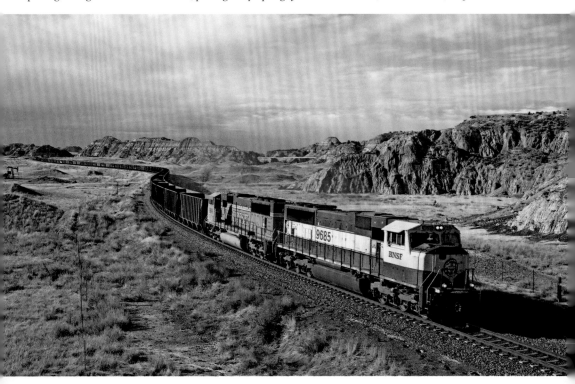

BNSF SD70MAC 9685, built by EMD in 1995 for the BN and still in its BN Executive livery, and SD70MAC 9849, built by EMD in 1997, are seen leading an eastbound rock train near Sully Springs, North Dakota, on 31 March 2012.

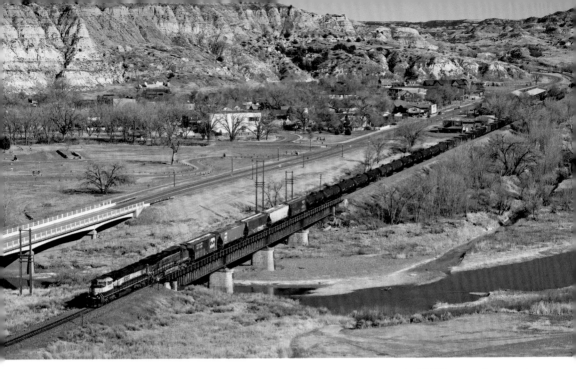

BNSF SD70MAC 9786, built by EMD in 1997 and delivered to the BNSF in the BN Executive livery, and more modern ES44AC 6168 are seen leading a westbound manifest through the town of Medora, North Dakota, crossing the Little Missouri River on 31 March 2012.

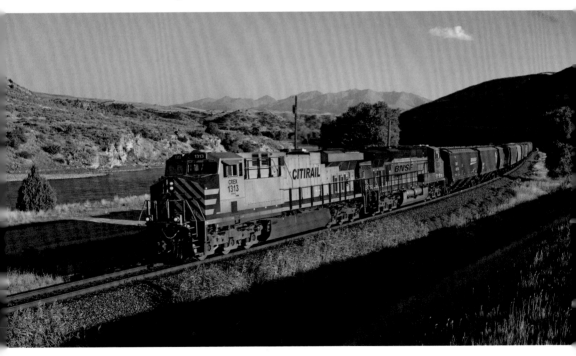

In 1987 Montana Rail Link (MRL) was created to lease the former Northern Pacific Main Line from Billings, Montana to Sandpoint, Idaho from the Burlington Northern. Here, Citirail-owned ES44AC 1313, built by GE in 2013 and on hire to BNSF, leads a westbound unit grain at Elton along the Yellowstone River east of Livingston, Montana, running over MRL trackage on 23 September 2014.

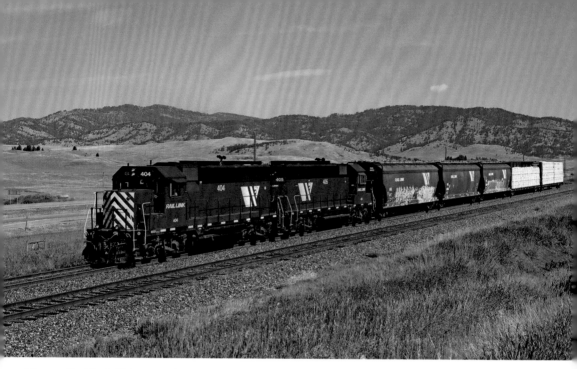

Montana Rail Link GP35 404 and 405, both former Rio Grande locos built by EMD in 1964 and 1965, are seen leading a short local freight west near the summit of Bozeman Pass at an elevation of 5,562 feet between Livingston and Bozeman, Montana, on 23 September 2014.

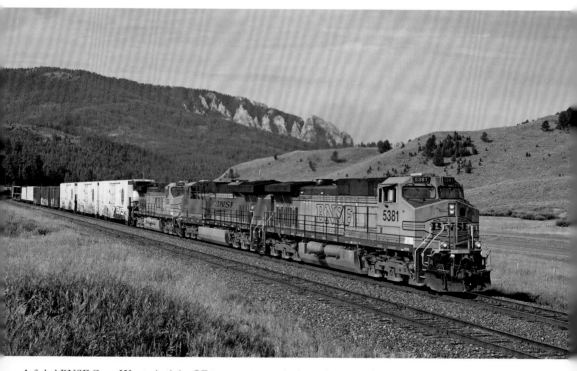

A faded BNSF C44-9W 5381, built by GE in 2000, is seen leading a heavy eastbound about to top the summit of Bozemen Pass between Bozeman and Livingston, Montana, on 30 August 2009. Heavy BNSF trains up Bozeman Pass will have MRL helpers added at Livingston or Bozeman for the trip over the pass.

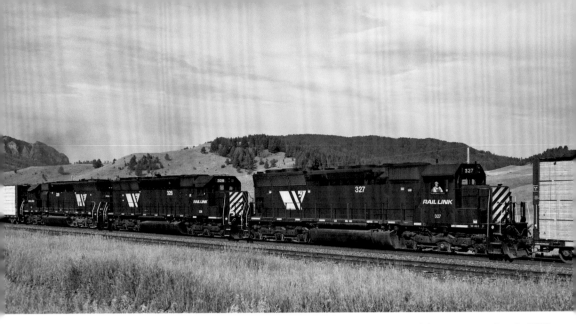

Montana Rail Link once had a large fleet of EMD SD45s, purchased second-hand from various railroads. MRL upgraded all their SD45s to SD45-2 specifications. However, the last of the class was withdrawn in 2016. Here are the mid-train helpers on the train shown previously, MRL SD45-2 327, 328 and 329 – all former Southern Pacific SD45s built between 1966 and 1969.

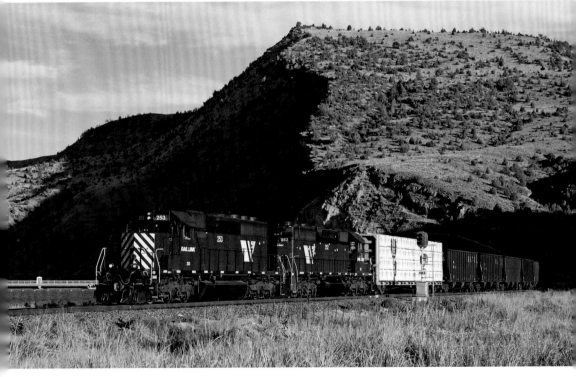

Between Logan and Toston, Montana, the Montana Rail Link main line passes through the scenic Lombard Canyon of the Missouri River. On 11 September 2013, Montana Rail Link SD40-2XR 253 (built by EMD in 1971 for the Burlington Northern) and 252 (built by EMD in 1966 for the Union Pacific) are seen leading a local from Helena to Logan through Lombard Canyon. Both were built as standard SD40s and rebuilt by MRL into SD40-2XRs.

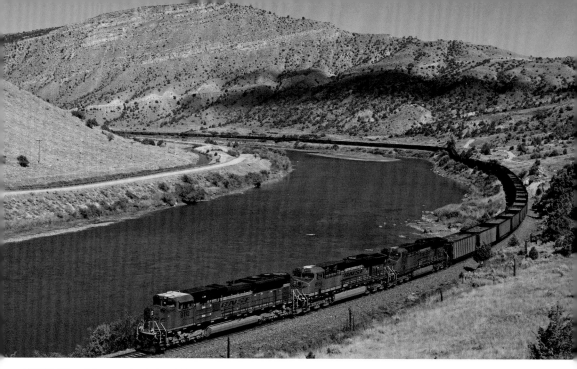

BNSF SD70ACe 9112, built by EMD in 2012, is seen in Lombard Canyon alongside the Missouri River on 11 September 2013, leading an eastbound empty coal train back to the Powder River Basin for another load of export coal to ship via the Pacific North West.

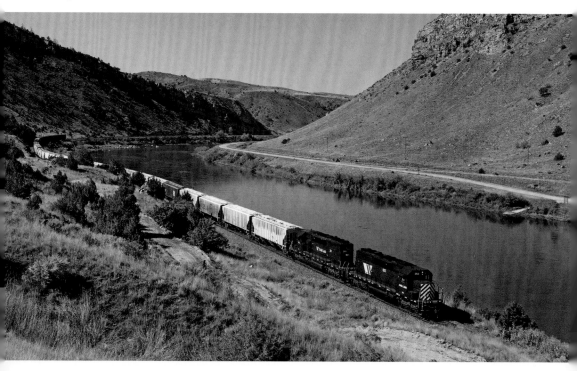

Montana Rail Link SD40-2XR 263, built in 1966 for the Chicago North Western, and 261, built in 1971 for the Burlington Northern (both as SD40s and rebuilt by MRL into SD40-2XRs) are seen leading a local freight from Logan to Helena, Montana, in Lombard Canyon on 24 September 2014.

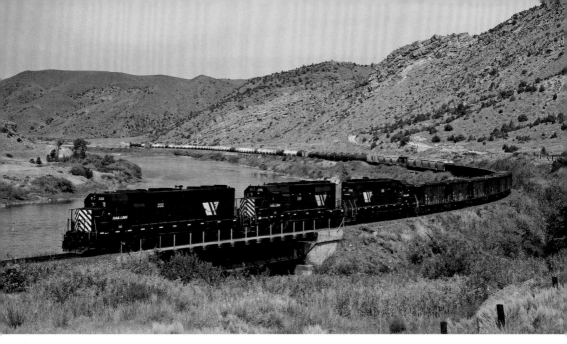

Montana Rail Link SD45-2 332 is seen with two SD40-2XR – 259 and 256 – working a Missoula to Laurel, Montana, manifest east through Lombard Canyon on 30 August 2009. Montana Rail Link 332 has an interesting history, being built by EMD for the Erie Lackawanna as a SDP45 in 1970. A SDP45 is a SD45 built with a steam boiler to heat passenger trains. However, this loco was wrecked in the mid-1970s and was rebuilt as a normal SD45-2 as the boiler was no longer required. The loco was purchased by MRL in the mid-1990s from Conrail, which absorbed the Erie Lackawanna in 1976.

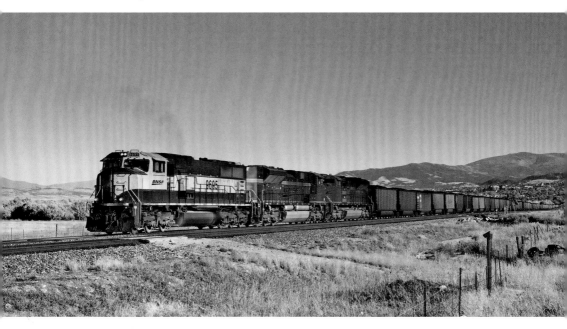

West of Helena the railway climbs to Mullan Pass where the line crosses the summit in a tunnel at an elevation of 5,566 feet. Much of this section is on a 2.2 per cent grade (1 in 45) which is the steepest section on the MRL main line. On 25 September 2014, BNSF SD70MAC 9695, built by EMD for the BN in 1995, is seen leading a unit coal train up Mullan Pass at Tobin with four MRL SD70ACes as helpers mid-train and another BNSF loco working as a DPU bringing up the rear. The mid-train helpers will be removed at Elliston just west of the summit.

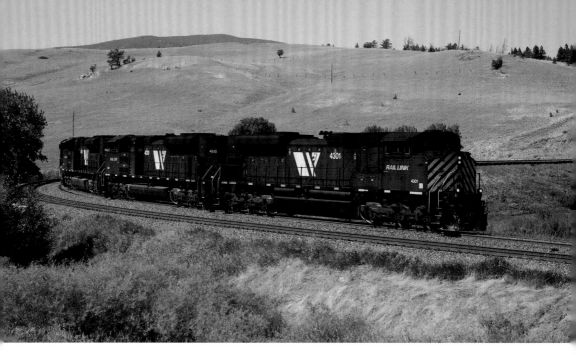

In 2005 Montana Rail Link took delivery of their first new locos – a fleet of sixteen SD70ACe built by EMD to be used mainly on helper service for Mullan Pass, numbered 4300-4315. This was later followed up by nine more locos in 2013 and 2014 due to increases in traffic. Here on 30 August 2009, MRL SD70ACe 4301 is seen with three more classmates downgrade at Austin, having helped a westbound train over Mullan Pass.

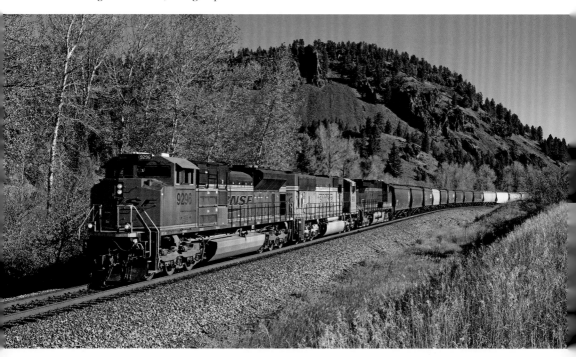

The west side of Mullan Pass is on a gentler grade than the east side, so helpers are not normally required for eastbound trains. On 25 September 2014, BNSF SD70ACe 9296, built by EMD in 2008, with SD70MAC 9838 and C44-9W 5282 are seen leading a westbound loaded unit grain train near Avon, Montana, descending the west side of Mullan Pass.

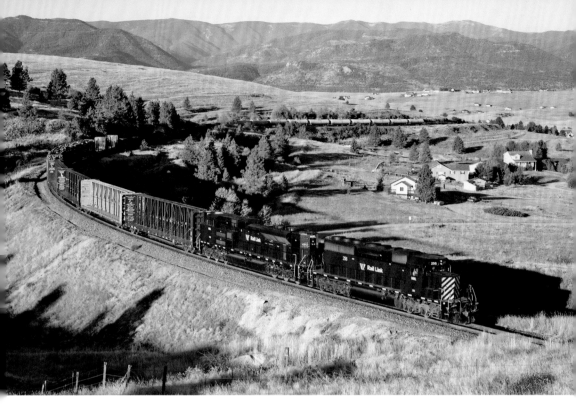

West of Missoula, Montana, there are two separate routes to Paradise. The northern route was the original route; however, with grades of 2.2 per cent (1 in 45) on the east side of Evaro Hill, a longer but much flatter route was built following the Clark Fork River. Today the Evaro Hill line is mainly used for empty eastbound trains and sometimes local traffic. On 10 September 2013, Montana Rail Link SD40-2XR 256, built by EMD in 1971 for the Burlington Northern, and MRL SD70ACe 4312, built in 2005, are seen with a local freight climbing up Evaro Hill out of Missoula.

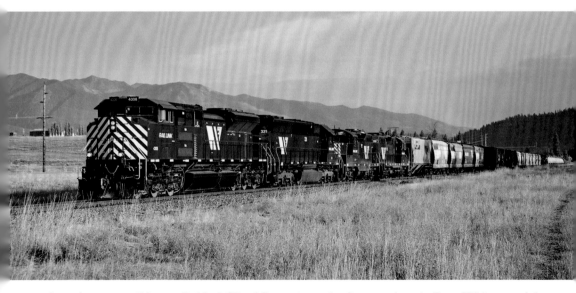

On 30 August 2009, Montana Rail Link SD70ACe 4308 is seen heading west along the Evaro Hill line near Arlee, Montana, with SD45 331 on a local freight. The two GP9s behind (127 and 113) will form another local freight from Paradise.

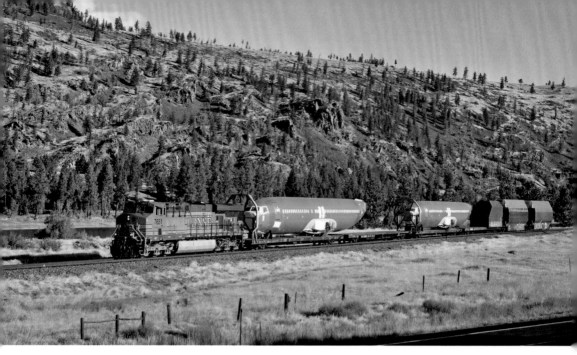

Boeing 737 fuselages are a regular sight being transported by train from Wichita, Kansas, to Seattle, Washington, for final assembly. On 26 September, 2014 BNSF ES44DC 7651, built by GE in 2005, is seen leading two fuselages with two cars of Boeing parts behind heading west along the Evaro Hill line near Perma, Montana, along the Flat Head River.

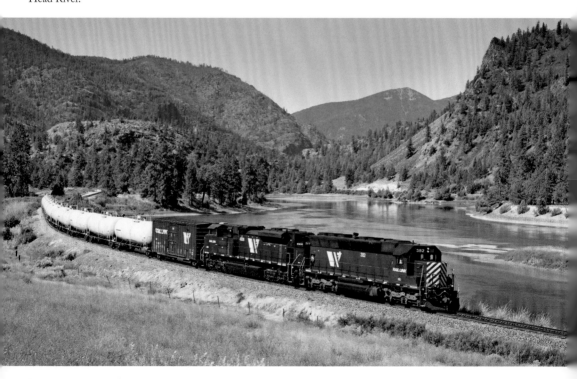

Montana Rail Link SD45R, built as a SD45 for the Seaboard Coast Line by EMD in 1971, and SD70ACe 4308, built by EMD in 2005, are seen leading a local freight east alongside the Flat Head River east of Perma, Montana, on 31 August 2009.

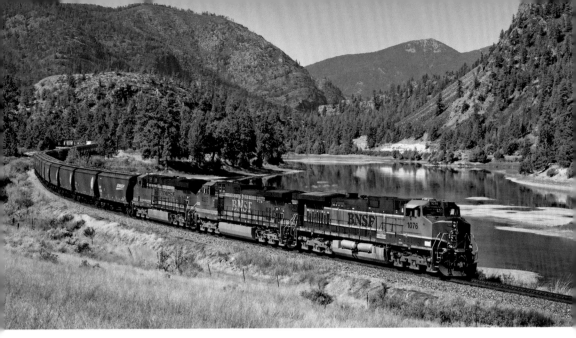

BNSF C44-9W 1076, built by GE in 1996, is seen leading an eastbound empty grain train on the Evaro Line on 10 September 2013. It is common for empty eastbound trains to use this route to free up capacity on the mainline.

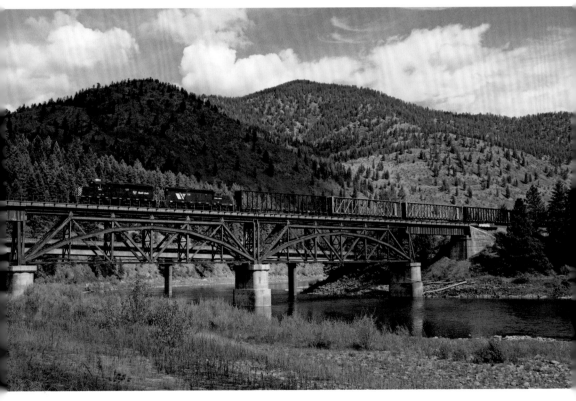

Most traffic uses the longer mainline between Missoula and Paradise following the Clark Fork River. On 26 September 2014, Montana Rail Link GP9 127, built by EMD in 1954 for the Great Northern, and 120, built for the Northern Pacific in 1957, are seen crossing the Clark Fork River between Paradise and St Regis on a local freight from Paradise.

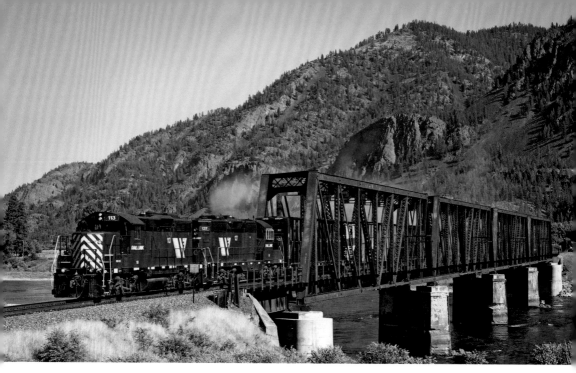

Montana Rail Link GP9 113, built in 1957 for the Northern Pacific, and 120, built in 1957 for the Great Northern, are seen leading a local south out of Paradise, Montana, over the Clark Fork River heading for St Regis on 31 August 2009.

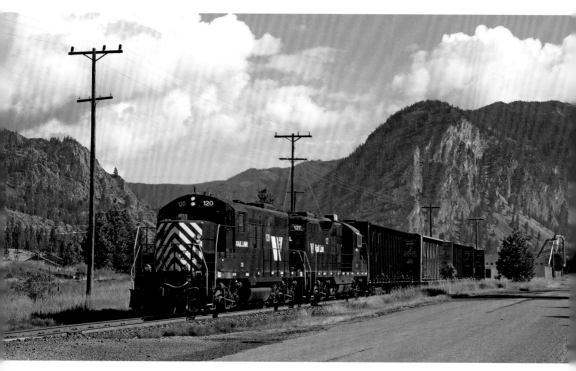

Montana Rail Link GP9 120, built for the Great Northern in 1957, and 127, built for the Great Northern in 1954, are seen switching the lumber mill at Thompson Falls before returning with a local freight to Paradise, Montana, on 26 September 2014.

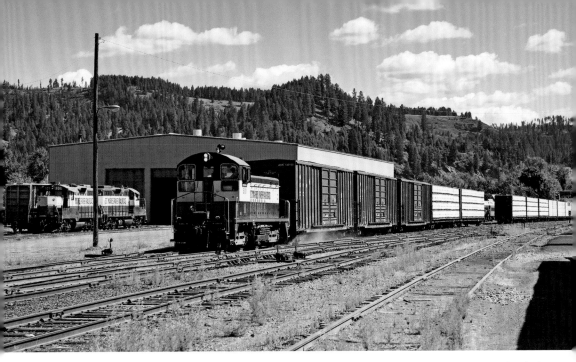

Until 1980, the Chicago, Milwaukee, St Paul & Pacific Railroad – known as the Milwaukee Road – had a trans-continental route to the Pacific. When the western extension was abandoned in 1980, the section of former Milwaukee Road mainline from St Maries to Plummer, Idaho, was taken over by the St Maries River Railroad. On 9 September 2013, St Maries River Railroad SW1200 501, built by EMD in 1954 for the Milwaukee Road, is seen switching in St Maries.

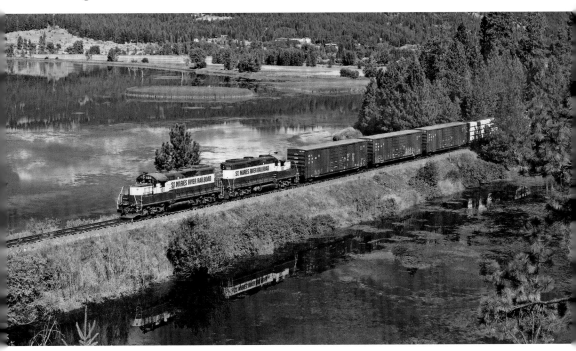

St Maries River Railroad GP9s 101 and 102, both built by EMD in 1959 for the Milwaukee Road, are seen working a freight from St Maries to Plummer, Idaho, beside Chatcolet Lake on the former Milwaukee Road mainline on 9 September 2013.

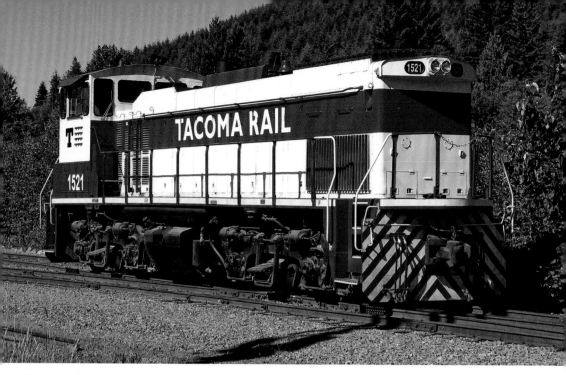

Tacoma Rail Switcher MP15 1521, built by EMD in 1983 for Ferrocarriles Nacionales de México (Mexico National Railways), is seen at Morton, Washington, on what was at one time a former Milwaukee Road branch line from Tacoma on 29 July 2005.

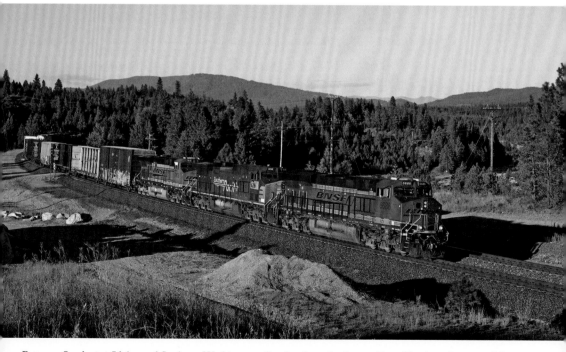

Between Sandpoint, Idaho, and Spokane, Washington, all trains from the former Great Northern Line over Marias Pass and the former Northern Pacific Line, now Montana Rail Link, come together on a section of track known as 'The Funnel'. On 9 September 2013, BNSF ES44C4 6686, built by GE in 2011, is seen leading a westbound manifest on the Funnel at Granite, Idaho.

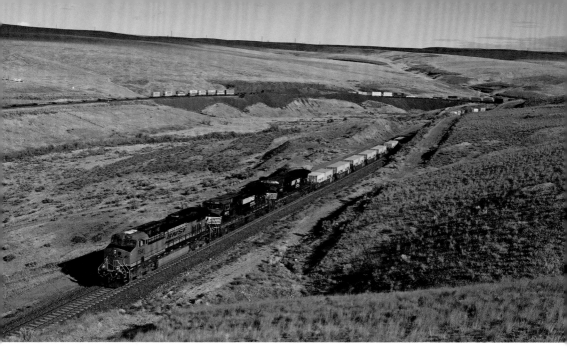

The former Great Northern Route between Spokane and Seattle is mainly used for intermodal traffic while heavier trains use a different route via Portland. On 7 October 2011, BNSF ES44DC 7541, built by GE in 2007, is seen leading an eastbound double stack train rounding Trinidad Loop near Quincy, Washington, climbing out of the Columbia River Gorge heading for Spokane.

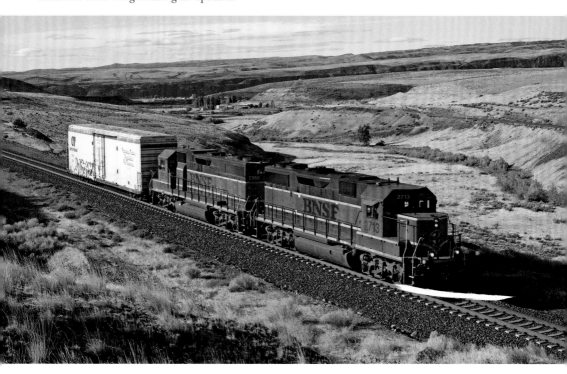

BNSF GP38-2 2713, built by EMD in 1981 for the BN, is seen leading a very short local from Quincy to Wenatchee, Washington, descending Trinidad Loop on 7 October 2011. The Columbia River Valley can be seen in the background.

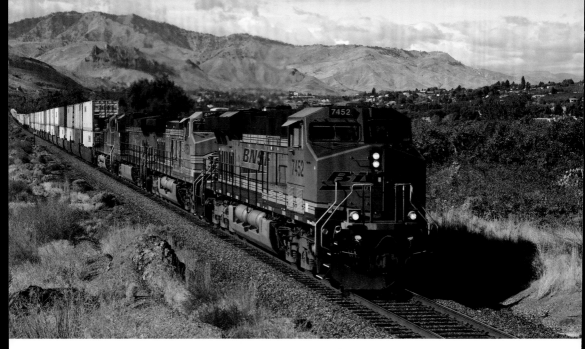

Leaving Wenatchee, Washington, BNSF ES44DC 7452, built by GE in 2008, is seen leading an eastbound high-priority Z train from South Seattle to Chicago on 7 October 2011.

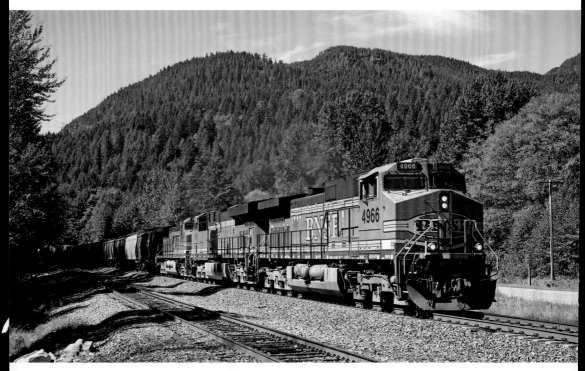

West of Wenatchee the line climbs up Stevens Pass to the 7.8-mile-long Cascade Tunnel at an elevation of 2,881 feet. West of the Cascade Tunnel the line is on a steep descent to Skykomish, Washington. At one time, due to the length of the Cascade Tunnel, the line was electrified between Wenatchee and Skykomish. However, the wires were removed with the advent of modern diesels. On 10 September 2009, BNSF C44-9W 4966, built by GE in 1998, is seen working an eastbound empty grain train climbing out of Skykomish.

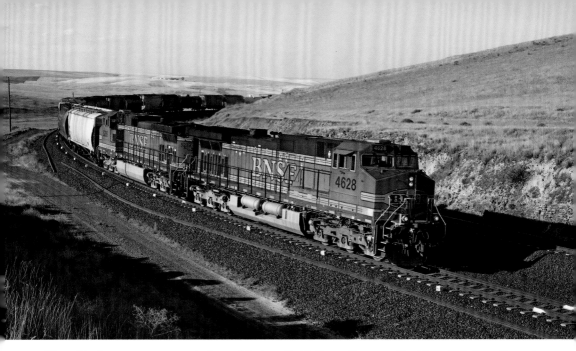

West of Spokane most trains use the former Northern Pacific line to Pasco over Providence Hill. On 10 September 2010, BNSF C44-9W 4628, built by GE in 2000, is seen leading a westbound manifest at the summit of Providence Hill near Lind, Washington.

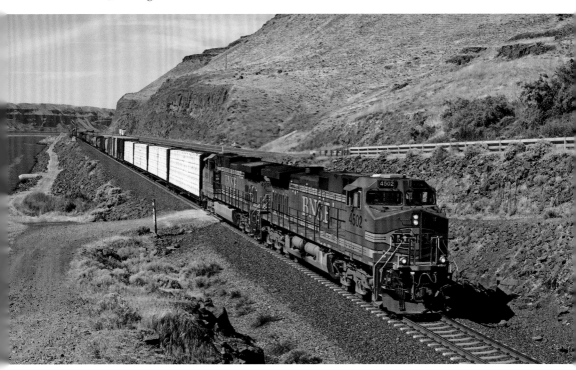

At Pasco the line splits with most trains using the former Spokane Portland & Seattle route via the flat Columbia River Gorge to Portland while the former Northern Pacific route crosses Stampede Pass to Seattle. On 11 September 2010, BNSF C44-9W 4502, built by GE in 1999, is seen leading an eastbound manifest train to Pasco at Bates in the Columbia River Gorge.

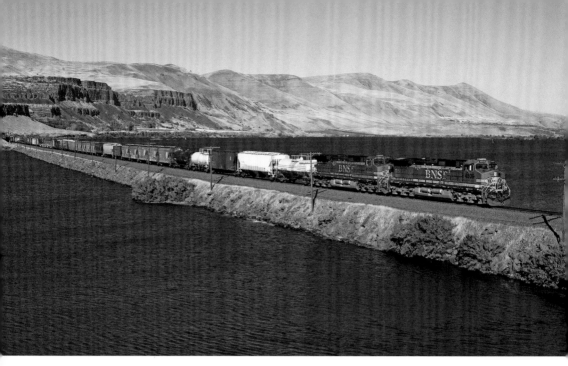

The Columbia River has multiple dams which, when built, resulted in the railways having to be relocated to a higher level. On 12 September 2010, BNSF C44-9W 4809, built by GE in 1998, is seen leading a westbound manifest at Horse Thief Lake just east of the Dalles Dam.

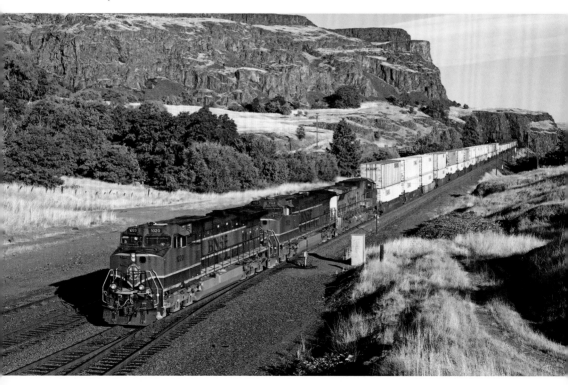

BNSF C44-9W 1020 built by GE in 1996 and delivered in the first BNSF merger paint scheme is seen leading a westbound high-priority Z train from Chicago to Portland west at Lyle, Washington, on 11 September 2010.

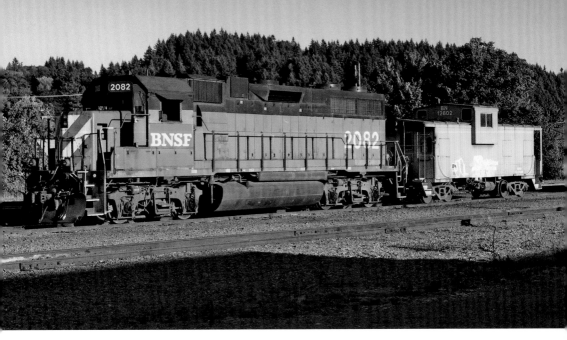

BNSF GP38-2 2082, built for the BN in 1972, is seen at Centralia, Washington, between Portland and Seattle on 28 July 2005. The caboose behind is still used on some local trains where reverse moves need to be made. Both the loco and the caboose are still in the BN cascade green livery.

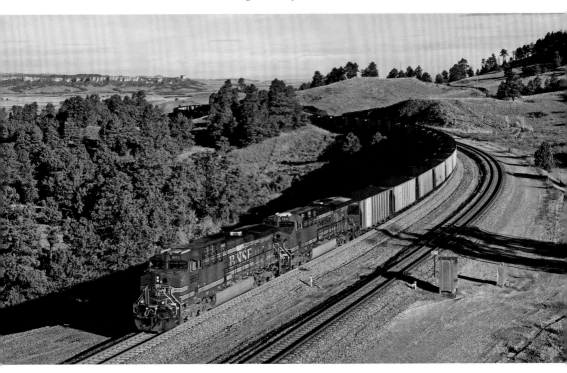

The development of Western Coal resources required the upgrading of several lines. One of the main routes upgraded for coal heading east out of the Powder River Basin was Crawford Hill. On 1 October 2013, BNSF AC4400CW 5653, built by GE in 2004, is seen leading a loaded coal train up Crawford Hill, Nebraska. A single DPU loco and two helpers, which will be removed at the summit, are bringing up the rear.

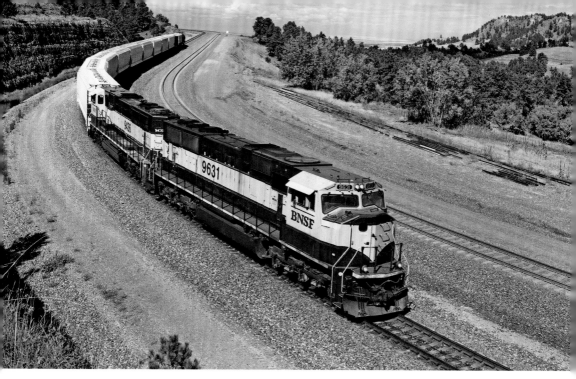

BNSF SD70MAC 9631, built by EMD in 1995 for BN coal service, and classmate 9436 are here seen on 1 October 2014, now restricted to local freight service from Alliance, descending Crawford Hill to Crawford, Nebraska.

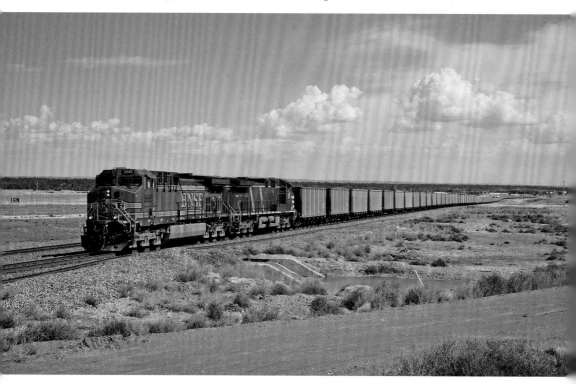

BNSF AC440CW 5685, built by GE in 2004, is seen leading an eastbound empty coal train returning to the Powder River Basin through Colloid, Wyoming, on 27 August 2009.

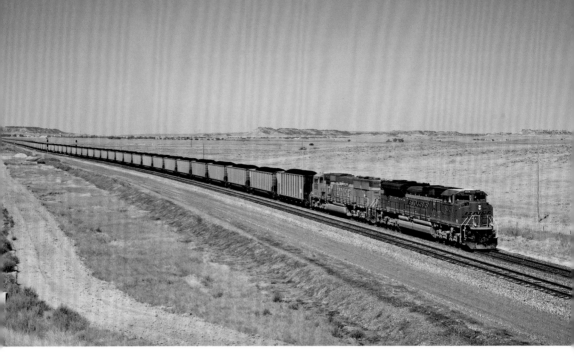

Having just turned east off the Powder River Basin line, BNSF SD70ACe 9228, built by EMD in 2008, is seen leading a loaded coal train near Rozet on 28 August 2009.

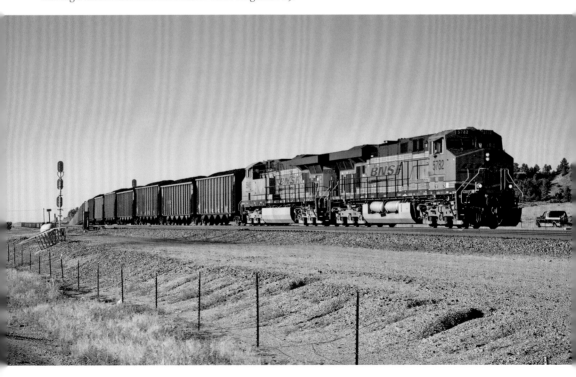

Between Rozet and Gillette, Wyoming is Donkey Creek Junction, which is the northern junction for the Powder River Basin line to Orin Junction near Douglas, Wyoming, which was completed in 1979 to serve the mines of the region. On the morning of 28 August 2009, BNSF ES44AC 5782, built by GE in 2005, and classmate 5946 is seen heading north approaching Donkey Creek Junction.

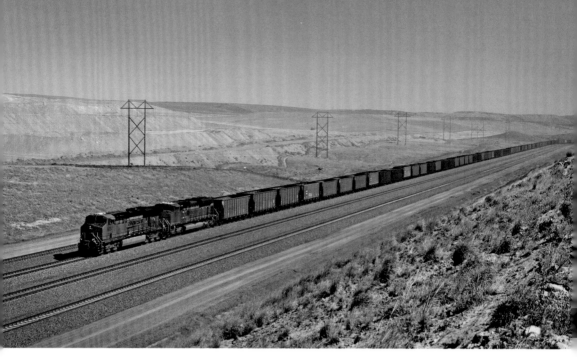

With coal dust in the air from recent blasting, BNSF ES44AC 6034, built by GE in 2006, is seen leading a northbound empty coal train through one of the Powder River Mines at West Nacco on 20 September 2014.

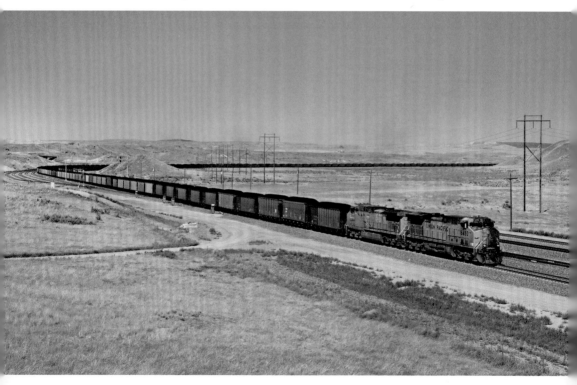

In 1984, the Chicago North Western Railroad started running coal trains from the Powder River Basin mines jointly with the Union Pacific. In 1995 the Union Pacific bought the Chicago North Western. On 20 September 2014, Union Pacific AC4400CW 6480, built by GE in 2000, is seen leading a southbound loaded coal train at Converse Junction.

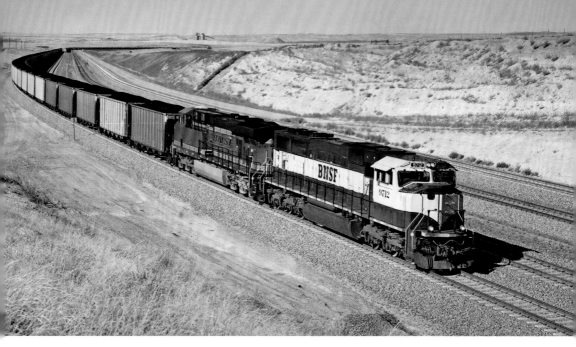

All trains going out the south end of the Powder River Basin have to climb up Logan Hill, where trains are often down to walking speed. On 15 September 2008, BNSF SD70MAC 9712, built in 1996 for the BN, along with a more modern ES44AC 6197 are seen leading a loaded coal train up Logan Hill, while a Union Pacific train in the distance has just started its climb up the hill.

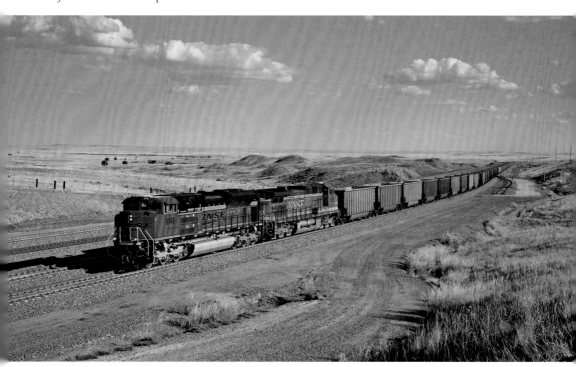

Bringing a train of empties back for loading in the Powder River Basin on 26 August 2009, BNSF SD70ACe 9146, built by EMD in 2007, and AC4400CW 5636 are seen leading a empty coal train north up Logan Hill.

Bill, Wyoming, has a yard for stabling UP trains and a coal car repair shop. The shop switcher is PRSX 408 – a former GP7 built for the Great Northern in 1950, which was rebuilt into a GP10 by the BN before being sold to the Iowa Interstate Railroad. The locomotive was later sold to Progress Rail and became the switcher at Bill where it is seen here on 27 August 2009.

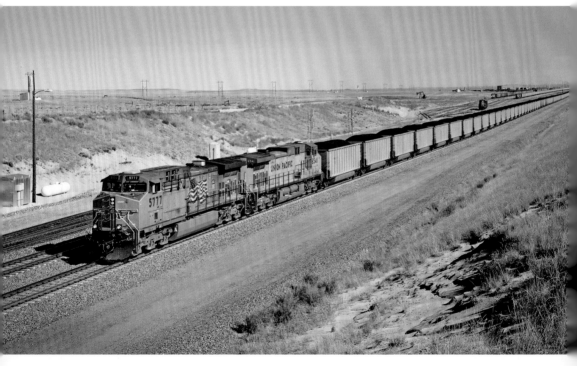

Just south of Bill Union Pacific, AC4400CW 5777, built by GE in 2002, and classmate 6541 are seen leading a loaded Powder River coal train south on 27 August 2009. All Union Pacific trains turn east off the main BNSF Powder River line at Shawnee Junction onto their own tracks.

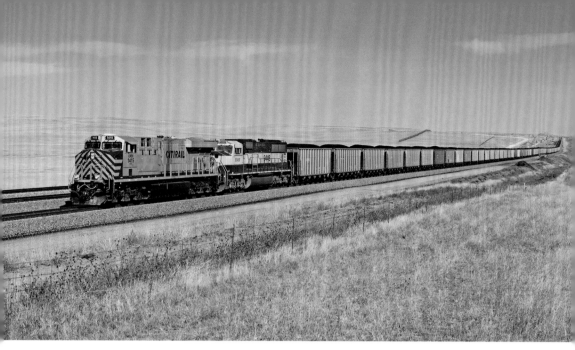

Citirail ES44AC 1415, built by GE in 2015, on long-term lease to BNSF with a much older SD70MAC 9448 are seen leading a southbound loaded coal train out of the Powder River near Lightning Creek on 20 September 2014.

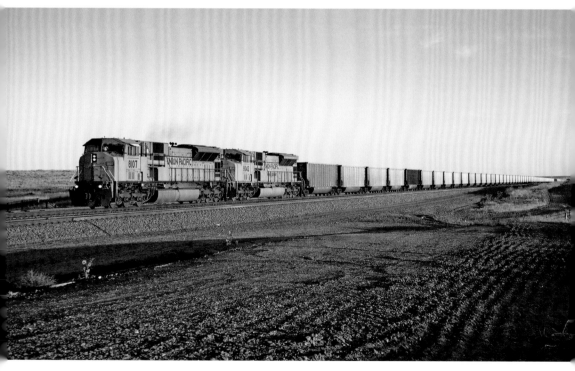

EMD introduced the SD9043MAC in 1995, which were delivered with a 4,300 hp engine that was later to be upgraded to a 6,000 hp engine. However problems with the higher horsepower engine meant no upgrades were ever carried out and by 2016 all the Union Pacific examples of the class were either sold or in storage. On 15 September 2008, a pair of SD9043MACs – with UP 8107 and 8042 – is seen with a northbound empty coal train south of Bill, Wyoming.

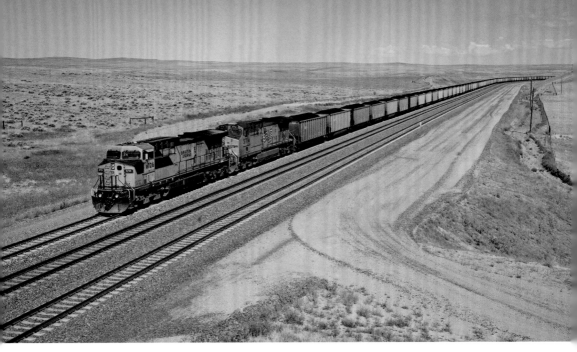

Still in its Chicago North Western livery but renumbered as Union Pacific 6726, this AC4400CW was built in 1994 by GE. On 26 August 2009, it is seen leading a loaded coal train south out of the Powder River Basin with a UP classmate at Walker, between Bill and Shawnee Junction, Wyoming.

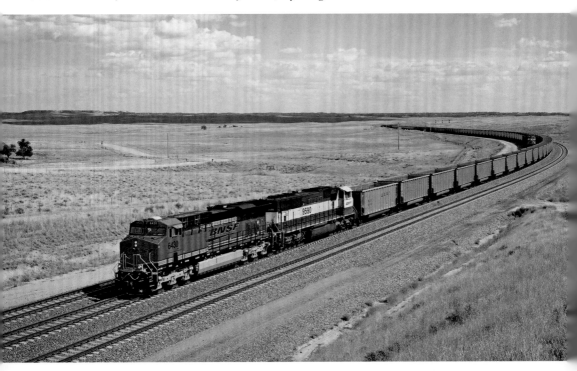

Returning back to the Powder River for another load of coal, a nearly new BNSF ES44AC 6430, built by GE in 2009, and a older SD70MAC 9590 are seen leading a northbound empty coal just north of Shawnee Junction, Wyoming, on 26 August 2009.

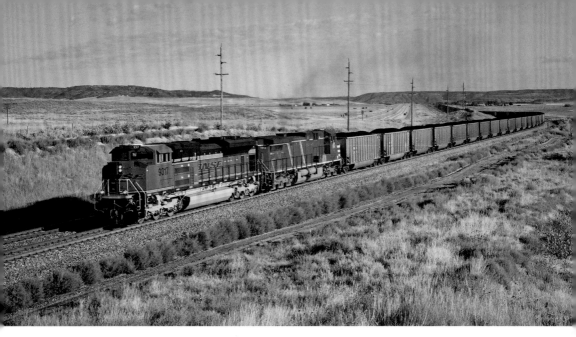

BNSF SD70ACe 9317, built by EMD in 2009, and lease loco CEFX AC4400CW 1014, built by GE in 2001, are seen leading a southbound loaded coal train from the Powder River Basin at Glendo, south of Bridger Junction where the Powder River coal line joins up with the Denver, Colorado, to Laurel, Montana, via Casper line on 26 August 2009.

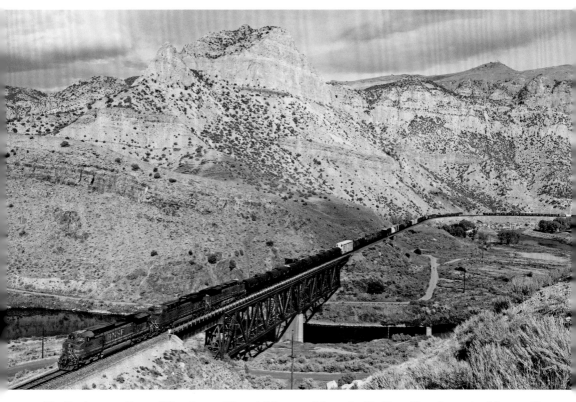

The line between Casper, Wyoming, and Laurel, Montana, follows the Big Horn River for much of the way. On 22 September 2014, BNSF C44-9W 4594, built by GE in 1999, with ES44C4 6890 and ES44AC 6327 are seen leading a southbound manifest exiting Wind River Canyon and crossing the Big Horn River at Boysen, Wyoming.

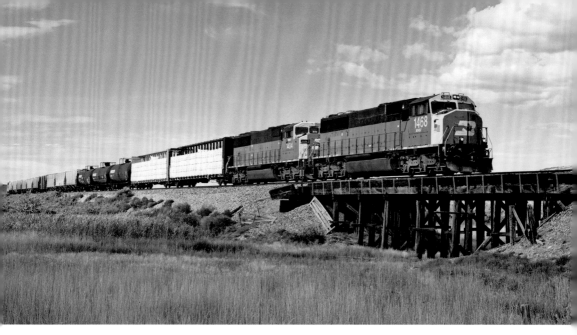

BNSF SD60Ms 1468 and 1404, built by EMD in 1991 and 1990 respectively, both still in BN cascade green livery, are seen leading a local freight for the Cody branch near Frannie, Wyoming on 22 September 2014. Note 1468 has two front cab windows while the slightly older 1404 has three windows in the front cab.

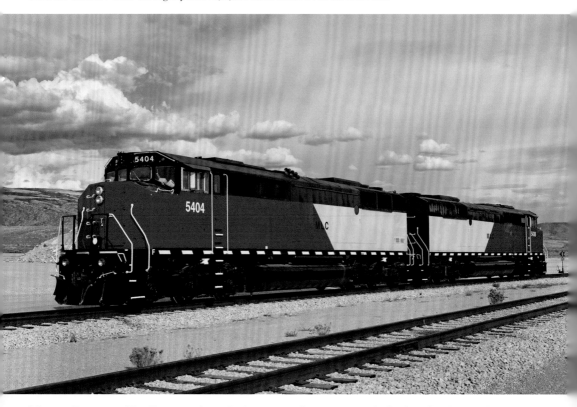

Montana Limestone SD50Fs 5404 and 5438, built in 1985 and 1986 respectively for Canadian National, are now owned by Montana Limestone and used for switching. They are seen at Limestone, south of Laurel, Montana, on 22 September 2014.

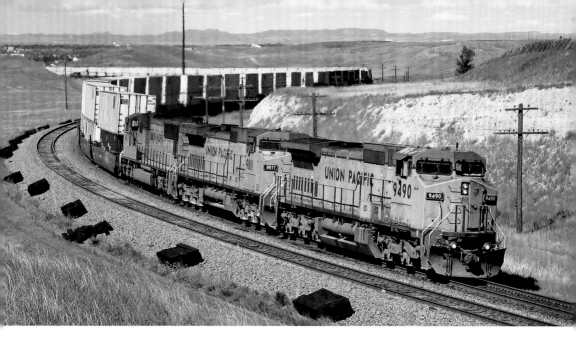

Moving on to the Union Pacific's historic Overland Route, Union Pacific C41-8W 9490 built by GE in 1993 is seen leading an eastbound high-priority Z train climbing Archer Hill east of Cheyenne, Wyoming, on 31 August 2004.

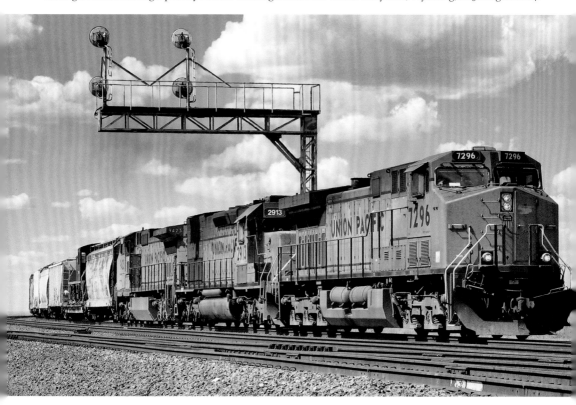

Between Cheyenne and Laramie, Wyoming, the Union Pacific Overland Route climbs Sherman Hill at an elevation of 7,960 feet. On 31 August 2004, Union Pacific AC4400CW 7296, built by GE in 1999, with SD40T-2 2913, built in 1977 by EMD for the Southern Pacific, and C41-8W 9423, built by GE in 1990, are seen leading an eastbound freight up Sherman Hill at Hermosa.

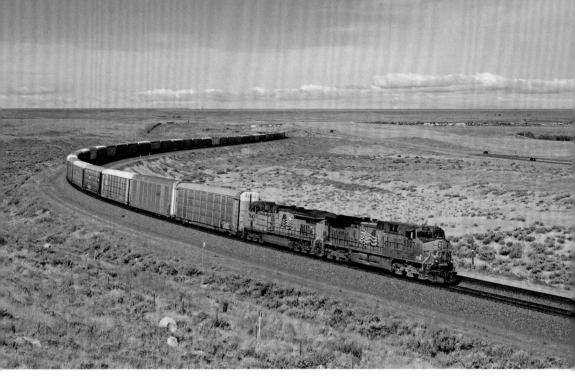

Union Pacific AC4400CW 5807, built by GE in 2002, and a more modern ES44AC 7843, built by GE in 2006, are seen leading an eastbound autorack train away from Rock River west of Laramie, Wyoming, on 2 October 2014.

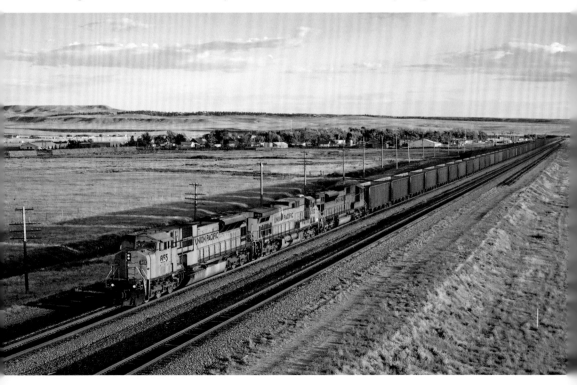

Union Pacific SD9043MAC 8155, built by GE in 1997, with AC4400CW 6782 and another SD9043MAC, 8153, are seen leading a westbound empty coal train passing Rock River, Wyoming, on 2 September 2007.

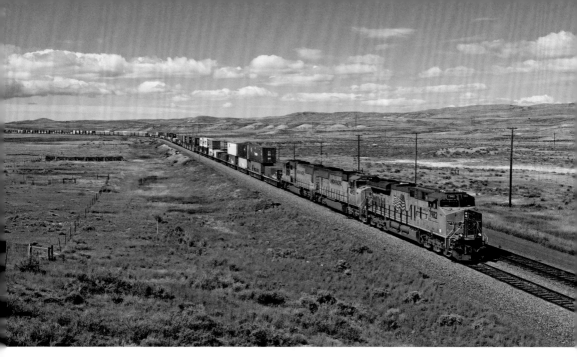

Union Pacific ES44AC 7982, built by GE in 2012, with SD70M 4692 and 4265 are seen leading an eastbound double stack train across the high plains of Wyoming, east of Hanna, Wyoming, on 2 October 2014.

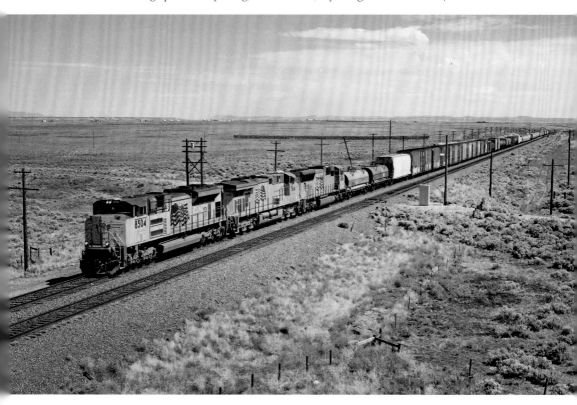

Thirty miles west of Rawlins, Wyoming, the Overland Route crosses the Continental Divide at Creston. On 2 September 2007, Union Pacific SD70ACe 8504, built by EMD in 2006, with ES44AC 7614 and SD70M 4936 are seen leading a westbound manifest climbing up to the summit at Creston.

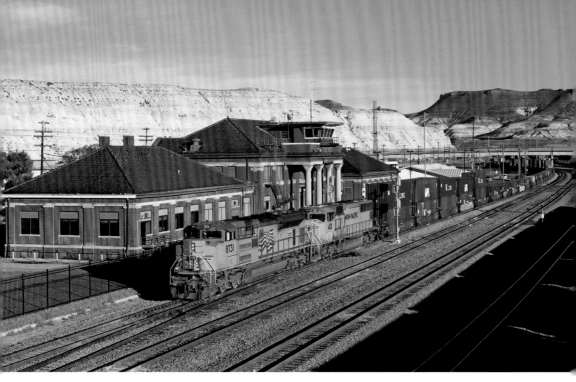

Union Pacific SD70ACe 8731, built by GE in 2012, and SD70M 4121 are seen passing the former station building at Green River, Wyoming, with a westbound double stack train on 3 October 2014.

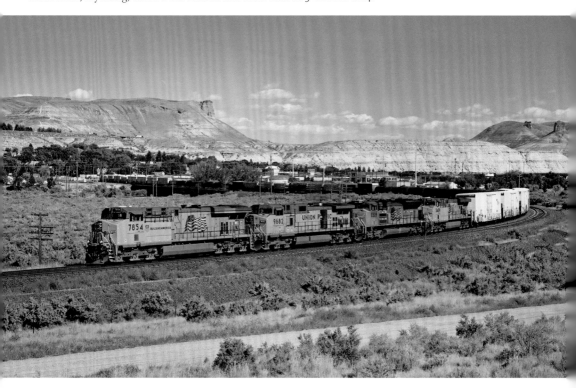

Union Pacific ES44AC 7854, built by GE in 2008, with C44-9W 9682, SD70ACe 8509, and ES44AC 5409 are seen leading a westbound manifest crossing the Green River, leaving Green River, Wyoming, on 21 September 2011.

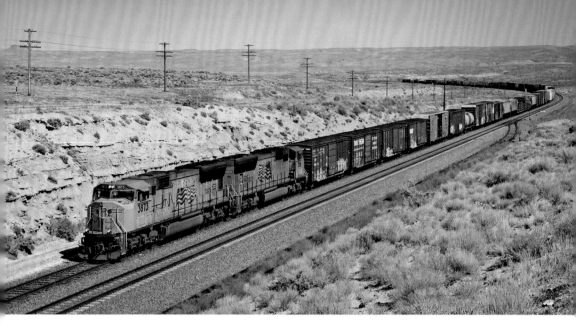

Union Pacific SD70M 3873 and 5116, built by EMD in 2004 and 2002 respectively, are seen leading a westbound manifest climbing Peru Hill west of Green River, Wyoming, on 13 September 2008. Just west of Peru Hill is the junction at Granger where the Overland Route continues west towards California, while the Oregon Short Line heads north to Oregon and the Pacific North West.

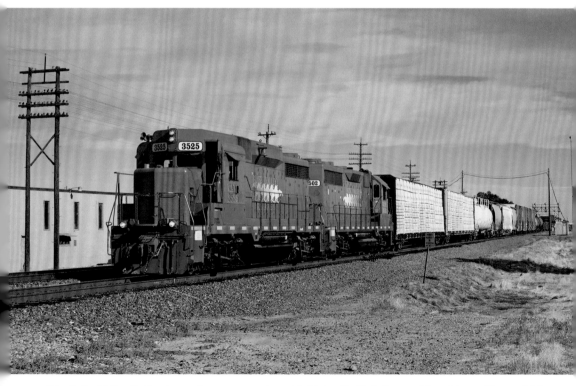

The Boise Valley Railroad runs from a connection with Union Pacific's Oregon Short Line at Nampa, Idaho to the state capital of Boise. On 15 September 2010, Boise Valley Railroad GP30M 3525, built in 1963 by EMD for the Chesapeake & Ohio as a GP30, and now owned by Web Asset Management and leased to the Boise Valley Railroad, is seen arriving at Nampa.

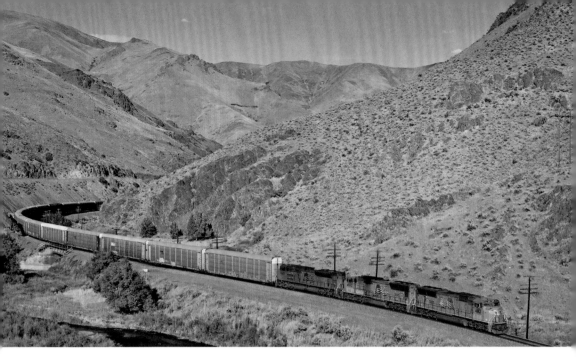

Having just crossed the Idaho–Oregon state line Union Pacific SD70M 4812, built by EMD in 2000, with SD70M 4972 and SD70ACe 8601, is seen leading a westbound autorack train just east of Huntington, Oregon, on 14 September 2010, where the steep climb over the Blue Mountain Summits begins.

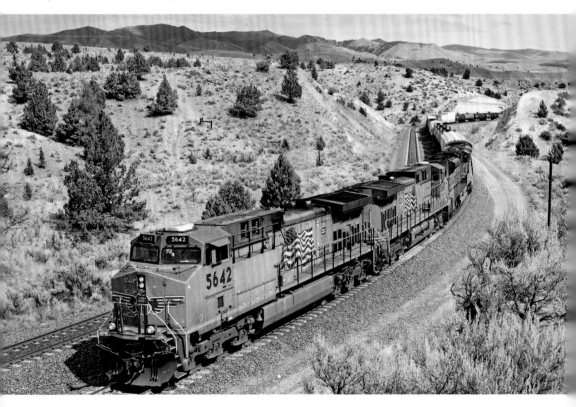

Union Pacific AC4400CW 5642, built by GE in 2004, with AC4400CW 5607 and two SD70ACes are seen climbing the 2.2 per cent (1 in 45) grade up to Encina Summit above Durkee, Oregon, with a westbound manifest on 15 September 2010.

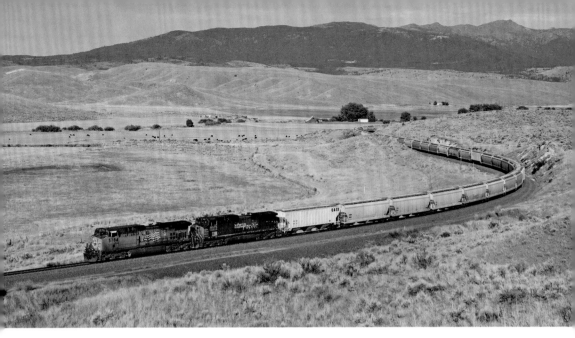

Union Pacific AC4400CW 5784, built by GE in 2002, and 6186, built by GE in 1995 for the Southern Pacific, and still in SP livery, are seen leading an eastbound empty grain train climbing to Encina Summit east of Baker City, Oregon, on 14 September 2010.

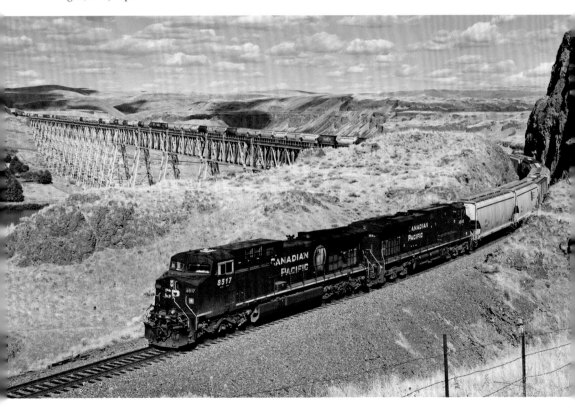

Canadian Pacific AC4400CW 8517, built by GE in 1998, and a more modern ES44AC 8880 are seen leading a westbound loaded grain train over the Snake River on Joso Viaduct on 8 September 2013. Joso Viaduct is on the Union Pacific line, which runs from Hinkle near Hermiston, Oregon, on the Oregon Short Line to Spokane, Washington, and a connection to Canada.

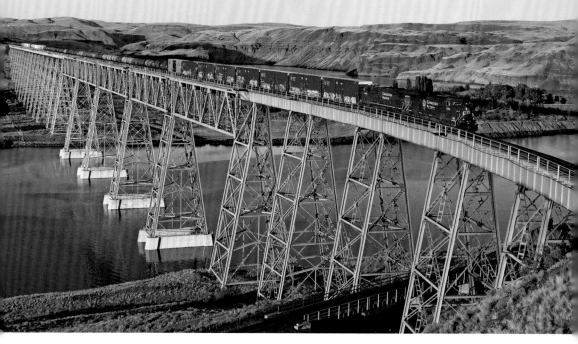

Canadian Pacific AC4400CW, built by GE in 1998, and a more modern ES44AC 8843 are seen leading a westbound manifest from Eastport on the Canadian border to Hinkle Yard crossing the Snake River on Joso Viaduct near Lyons Ferry, Washington. Canadian Pacific and Union Pacific share locomotives on trains from Hinkle to Lethbridge in Canada to avoid the need to change them at the border.

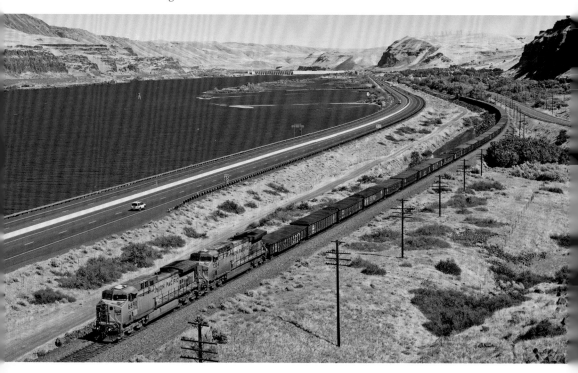

West of Hinkle, the Union Pacifc's Oregon Short Line to Portland follows the Columbia River on the south side with the BNSF Pasco to Portland line on the north side of the river. On 12 September 2010, Union Pacific 6690, built by GE in 1997, and AC4460CW 7324 are seen leading a westbound train of gondolas near Biggs, Oregon.

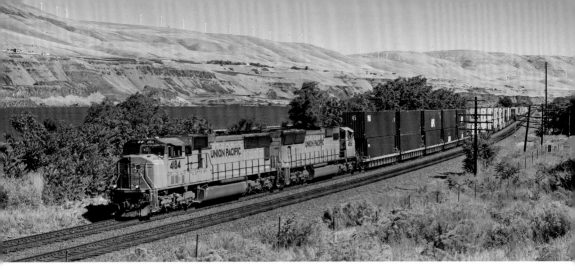

Union Pacific SD70Ms 4184 and 4861, built by EMD in 2000 and 2002 respectively, are seen leading a westbound double stack train heading for Portland at Biggs east of The Dalles, Oregon, on 12 September 2010.

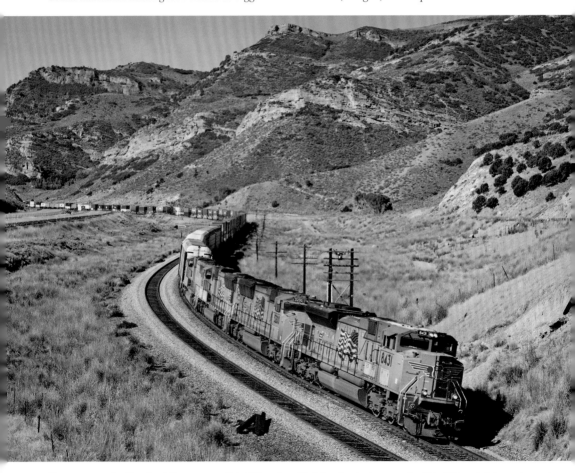

Returning to the Overland Route west of the Wyoming–Utah border, is the summit of the Wasatch Mountains and from here the Overland Route descends into Ogden through Echo and Weber Canyons. On 22 September 2011, Union Pacific SD70ACe 8431, built by EMD in 2006, is seen leading a high-priority eastbound Z train from Los Angeles to Denver, climbing upgrade in Echo Canyon at Emory, Utah.

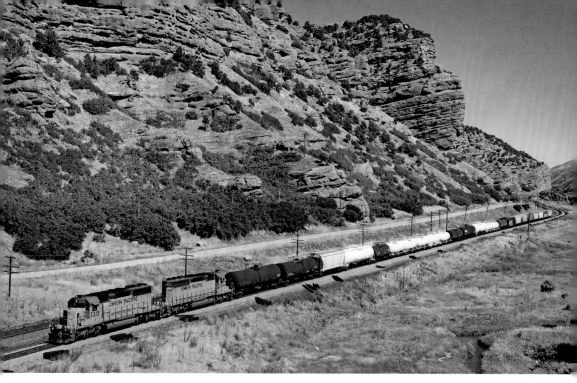

Union Pacific SD40-2 3215 and 3214, both built by EMD in 1973, are seen with a local freight from Evanston, Wyoming to Echo, Utah, on the approach to Echo on 23 September 2011.

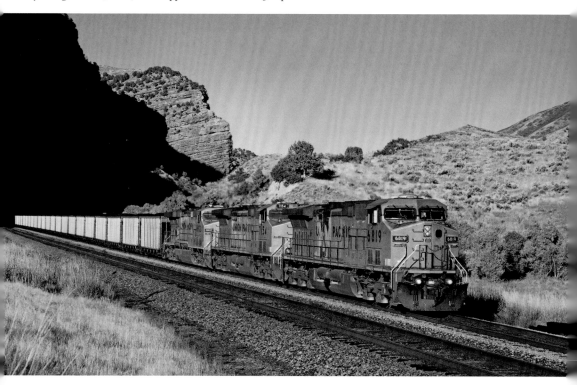

Union Pacific AC4400CW 6819, built by GE in 1996, with AC4400CW 7154 and AC4460CW 6902 are seen leading a westbound loaded coal train exiting Echo Canyon on the approach to Echo on 23 September 2011.

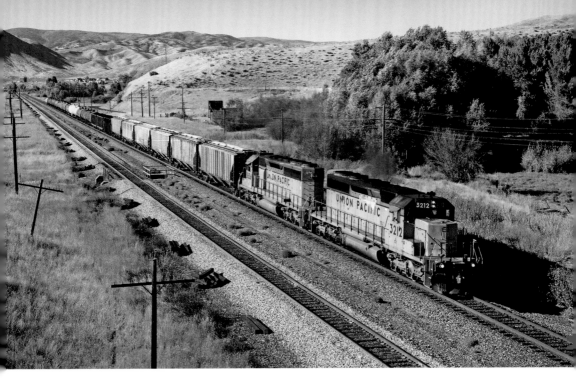

UP SD40-2s 3212 and 3656, built by EMD in 1973 and 1979 respectively, are seen leading an eastbound local freight from Ogden to Echo approaching Echo, Utah, on 23 September 2011.

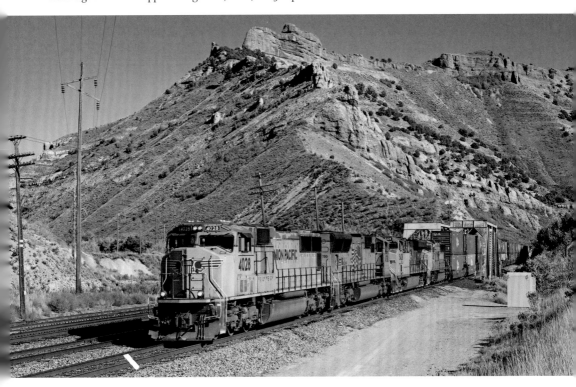

Union Pacific SD70M 4028, built by EMD in 2000, with SD70M 4780, ES44AC 5428 and SD70M 4262 are seen leading a westbound double stack train at Devils Slide in Weber Canyon on 4 October 2014.

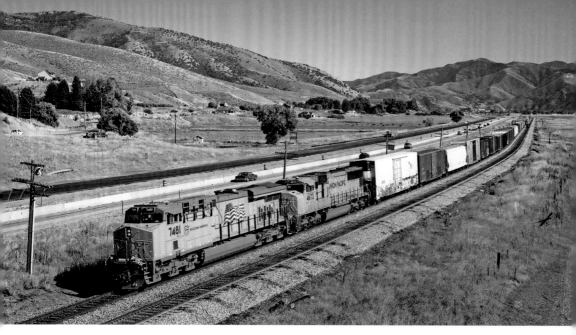

A recently delivered Union Pacific ES44AC 7481, built by GE in 2011, with SD70M 4672 are seen leading a westbound manifest from Green River to Salt Lake City at Morgan, Utah, on 22 September 2011.

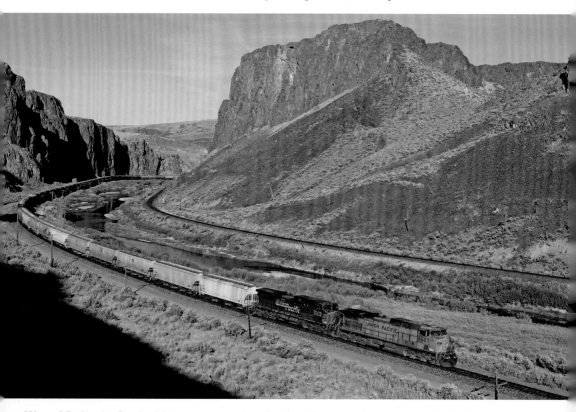

West of Ogden the Overland Route was part of the Southern Pacific until its merger with the Union Pacific. Paralleling the Southern Pacific on this section of line was the Western Pacific on their route from Salt Lake City to California. Both routes are now Union Pacific and used as double track. On 27 September 2011, Union Pacific AC4400CW 6607, built by GE in 1997, and 6230 still in its Southern Pacific livery, built by GE in 1995, are seen leading a westbound loaded grain train through Palisade Canyon west of Carlin, Nevada.

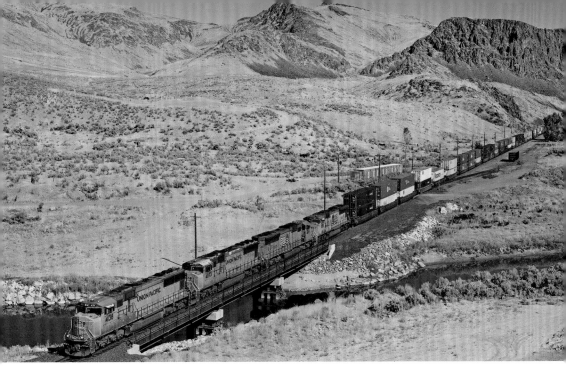

Union Pacific SD70M 4138, built by EMD in 2000, with three more SD70Ms – 4073, 4891 and 5155 – are seen leading a westbound double stack train at Palisade, Nevada, on 26 September 2011. The train is on the former Southern Pacific track, which is now used as the westbound track, while the former Western Pacific track is the eastbound track.

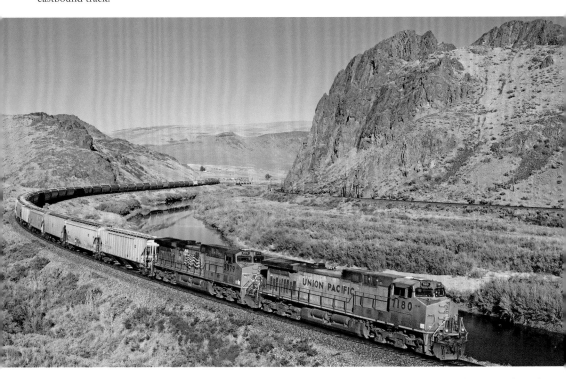

Union Pacific AC4400 7180 and 5979, built by GE in 1999 and 2003 respectively, are seen leading a westbound loaded grain train in Palisade Canyon alongside the Humboldt River on 26 September 2011. The eastbound former Western Pacific track can be seen on the other side of the river.

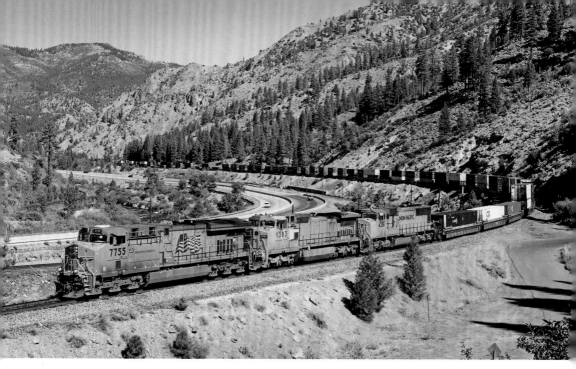

West of Reno, Nevada the line crosses into California and starts the climb over the Sierra Nevada using Donner Pass. On 28 September 2011, Union Pacific ES44AC 7755, built by GE in 2007, with C40-8W 9383 and SD70M 4358 are seen leading a westbound double stack train climbing upgrade in the Truckee River Canyon at Floriston, California.

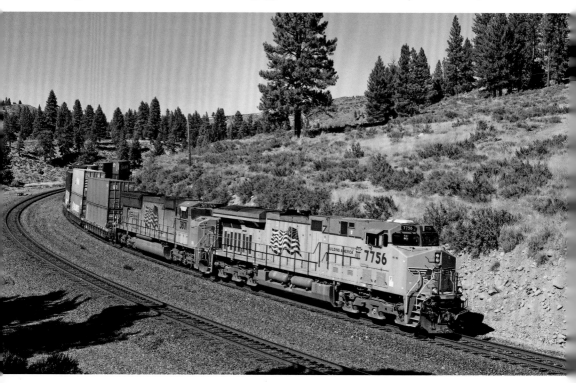

UP ES44AC 7756, built by GE in 2007, and SD70M 3871 are seen leading an eastbound double stack train descending Donner Pass at Hirschdale east of Truckee, California, on 28 September 2011.

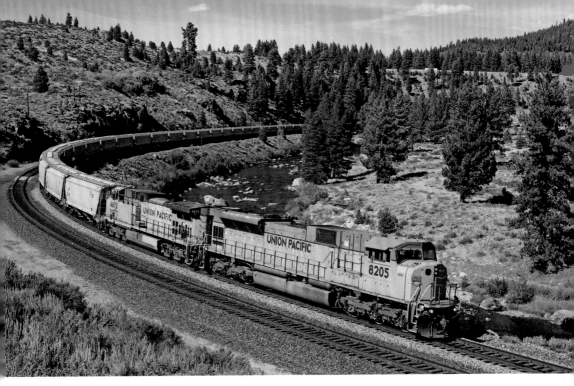

UP SD9043MAC 8205, built by EMD in 1998, and AC4400CW 6672 are seen leading a westbound loaded grain train along the Truckee River at Glenshire east of Truckee climbing up to Donner Pass on 29 September 2011.

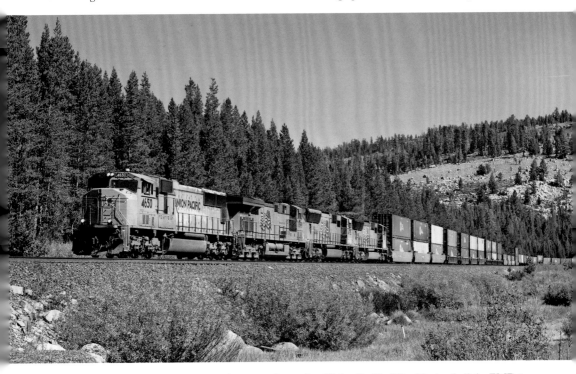

Having just crossed Donner Pass at an elevation of 6,972 feet, Union Pacific SD70M 4650, built by EMD in 2001, with ES44AC 7899 and two more SD70Ms are seen leading a westbound high-priority Z train at Soda Springs, California, on the long descent to the Pacific Coast on 28 September 2011.

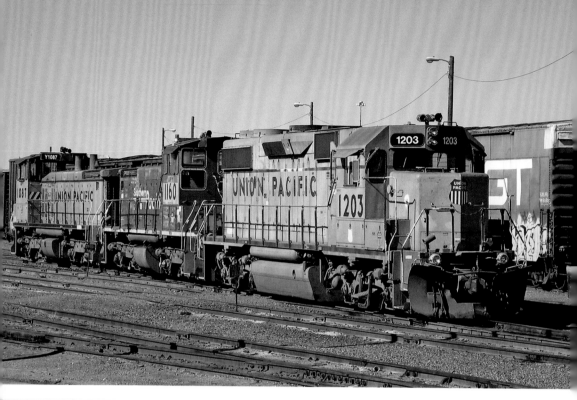

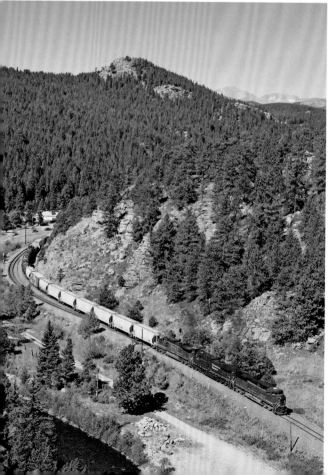

Above: Denver, Colorado was the start of the Denver & Rio Grande Western Railroad. Union Pacific 1203 was a GP39-2, built for Kennecott Copper in 1977. The loco was later sold to the Missouri Kansas Texas Railroad, which was purchased by the Union Pacific in 1988. The loco is now part of the Union Pacific fleet, used as local or switching power, and is seen here at the former Rio Grande North Yard in Denver on 1 September 2004. Behind are two EMD SW1500 switcher locomotives.

Left: The line west from Denver climbs up to the 6.2-mile-long Moffat Tunnel at an elevation of 9,239 feet, making it the highest active mainline in North America. When the Union Pacific merged with the Southern Pacific, BNSF were given trackage rights over the line to increase competition. On 19 September 2014, BNSF ES44DC 7338, built by GE in 2009, with a Canadian Pacific ES44AC and a BNSF C44-9W are seen leading a trackage rights manifest descending into Denver at Pinecliff, Colorado.

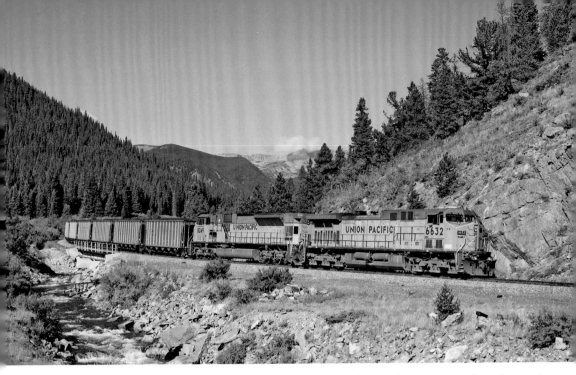

The line between Denver and the Moffat Tunnel climbs around 4,000 feet mostly on a 2 per cent (1 in 50) grade. On 24 August 2007, Union Pacific AC4400CW 6632, built by GE in 1997, and an EMD SD9043MAC 8249 are seen descending from the Moffat Tunnel near Rollinsville, Colorado, with a loaded coal train, with three more locos in the middle and one on the rear all working as DPUs.

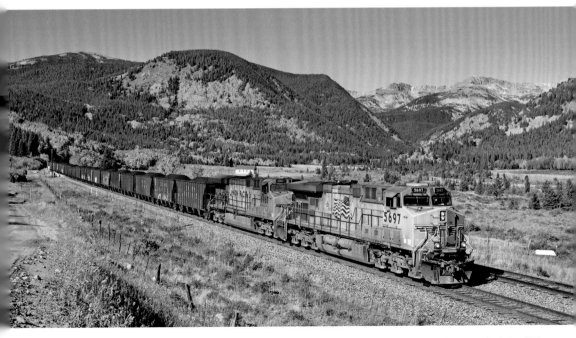

Having passed through the Moffat Tunnel a few miles previously Union Pacific ES44AC 5697, built by GE in 2003 as one of the prototype ES44ACs, is seen leading an eastbound loaded coal train downgrade at Tolland on 19 September 2014. Before the Moffat Tunnel was completed in 1928, the original railway route crossed Rollins Pass at an elevation of 11,660 feet.

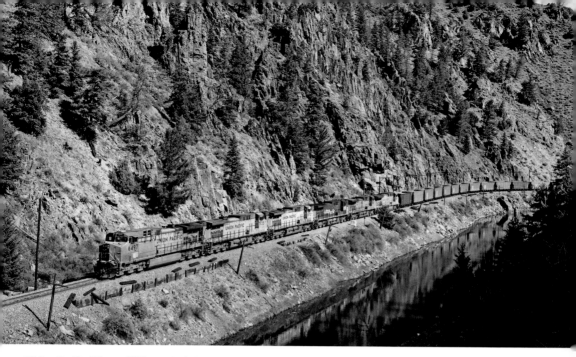

Union Pacific AC4400CW 6497, built by GE in 2000 with five other classmates, is seen in Byers Canyon along the headwaters of the Colorado River, west of Hot Sulphur Springs, Colorado, on 20 September 2011. It is leading a westbound empty coal train back to the mines of western Colorado for loading.

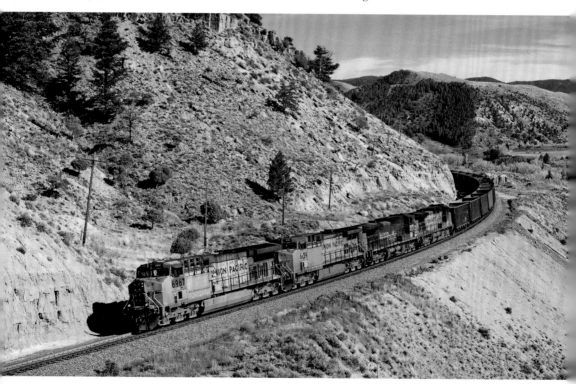

Union Pacific AC4460CW 6967 is seen leading an empty coal train west at Parshall, Colorado. UP 6967 was built by GE in 2001 as a 6,000 hp AC6000CW; however, due to reliability issues, the loco was de-rated to 4,400 hp. The back radiators differ from a standard AC4400CW.

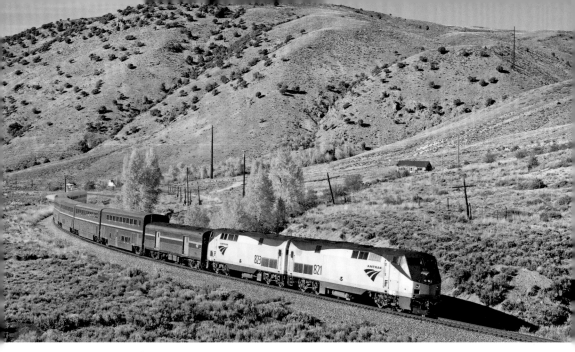

Amtrak P40s 821 and 823 are seen leading the eastbound California Zephyr from Oakland to Chicago at Parshall, Colorado on 7 October 2014. Forty-four P40s were built by GE in 1993 for Amtrak. However, once the more modern P42s were delivered, the P40s spent time in store and some examples have been sold to commuter railroads.

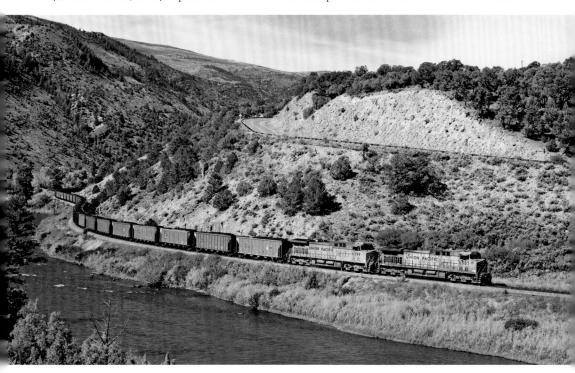

At Bond, west of State Bridge, Colorado, the line splits with the Craig Branch diverging to the north and climbing Toponas Summit, while the main line stays at river level and continues west to Glenwood Springs. On 7 October 2014, Union Pacific AC4400CW 6587, built by GE in 1997, is seen leading a westbound loaded coal from Energy Mine on the Craig Branch along the Colorado River at State Bridge.

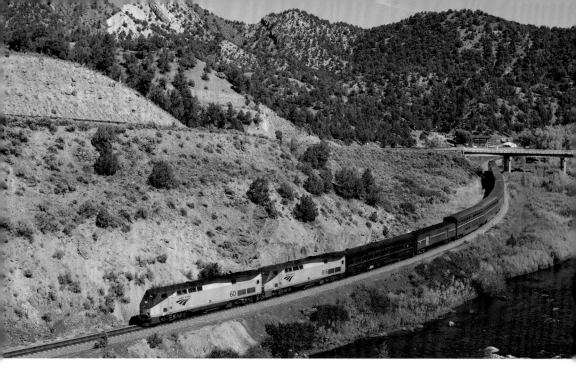

Amtrak's California Zephyr is seen heading west at State Bridge, Colorado, alongside the Colorado River with P42 60 and P40 816, built by GE in 1997 and 1993 respectively, on 7 October 2014. A Federal Railroad Administration Passenger Car is behind the locomotives.

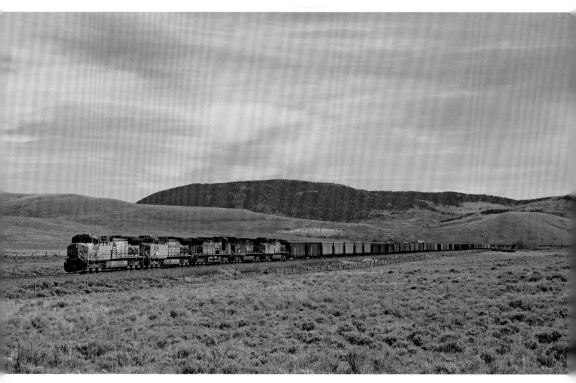

Having just topped Toponas Summit at an elevation of 8,284 feet on the Craig Branch Union Pacific, AC4400CW 6068, built by GE in 2004, is seen leading an empty coal train bound for Energy Mine on 7 October 2014.

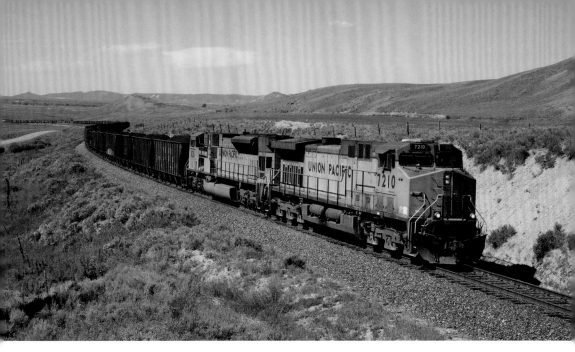

Union Pacific AC4400CW 7210, built by GE in 1999, and EMD SD9043MAC 8126 are seen leading a loaded coal train east up the 1.8 per cent (1 in 73) grade between Phippsburg and Toponas, Colorado. Three more locos are in the middle and one on the rear working as DPUs on 8 September 2008.

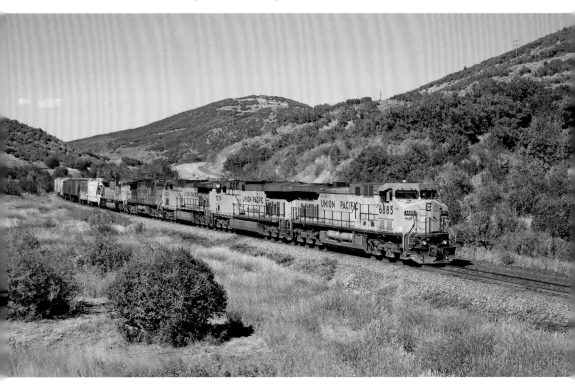

West of Phippsburg the line is relatively flat following the Yampa River Valley. Just west of Oak Creek, Colorado, Union Pacific AC4400CW 6885, built by GE in 1995, is seen leading a Craig-Phippsburg local freight east with four other locos on 8 September 2008. Note the yellow variations on each of the locos.

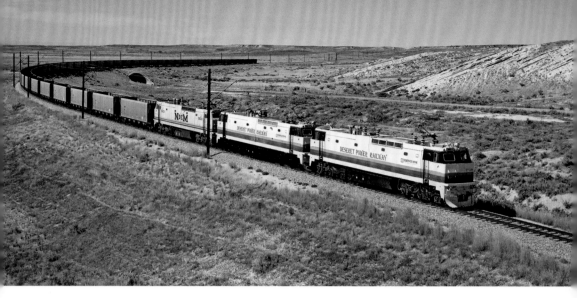

In 1984, a 35-mile isolated electric railway opened around 100 miles west of Craig on the Colorado–Utah border from Deserado Mine in Colorado to Bonzana Power Station in Utah. On 21 September 2011, Deseret Power Railway E60s 1 and 2, built by GE in 1984, and 3, built for the Ferrocarriles Nacionales de México (Mexico National Railways) in 1983 and later purchased by the Deseret Power Railway, are seen leading an eastbound empty coal train at Mormon Gap.

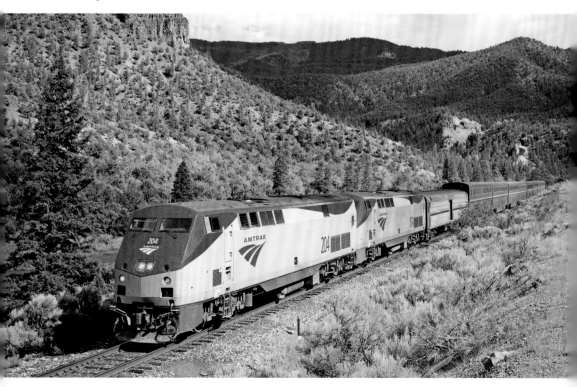

The mainline west of Bond continues to follow the Colorado River all the way to the Colorado–Utah border west of Grand Junction. On 29 August 2007, Amtrak P42 204, built by GE in 2001, and 154 are seen leading the eastbound California Zephyr from Oakland to Chicago.

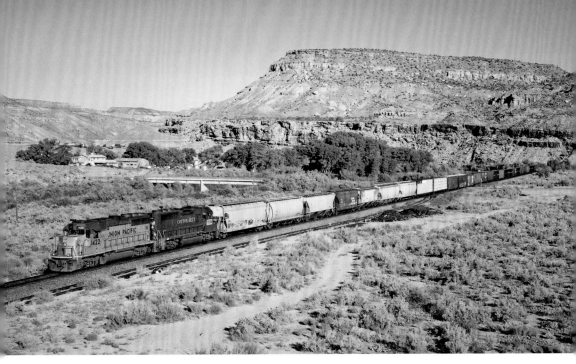

South of Grand Junction, named for where the Colorado and Gunnison Rivers meet, is a branch off the mainline following the Gunnison River to coal mines to the south east. The line also sees one local train a week to Montrose a branch off the line at Delta. On 5 September 2008, Union Pacific GP40-2 1422, built by EMD for the Southern Pacific in 1980, is seen leading the local south.

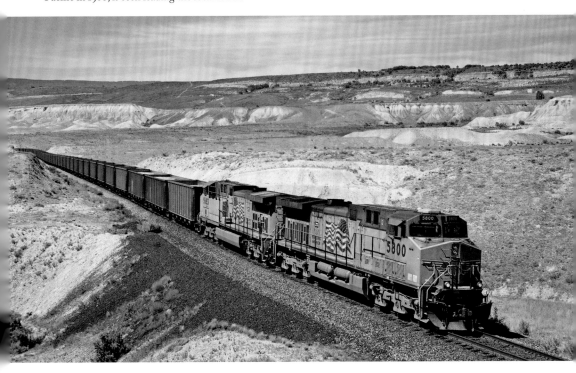

Union Pacific AC4400CW 5800, built by GE in 2002, is seen leading a southbound empty coal at Shamrock between Delta and Somerset, Colorado, on 5 September 2008.

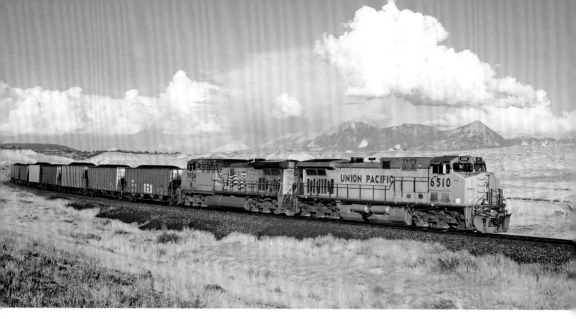

Union Pacific AC4400CW 6510 built by GE in 2000 is seen leading a northbound loaded coal train near the siding of Rodgers Mesa between Somerset and Delta, Colorado on 28 August 2007. Recently coal traffic on this route has dropped off to only a couple of trains each day.

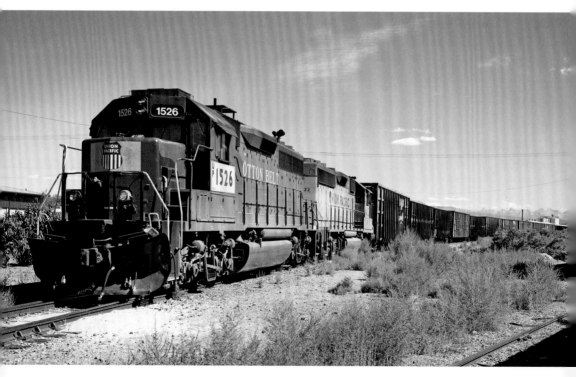

South of Delta another branch continues south to Montrose, Colorado. Union Pacific GP40M-2 1526 is still in the livery of the St Louis South Western. This was a subsidiary of the Southern Pacific known as the Cotton Belt. The loco was built by EMD in 1967 for the Louisville and Nashville Railroad, which later become part of the Seaboard Coast Line. The loco was purchased by the St Louis South Western and rebuilt as a GP40M-2, and became Union Pacific with their takeover of the Southern Pacific. The loco is seen on 5 September 2008 on the weekly local freight waiting to leave Montrose for Grand Junction.

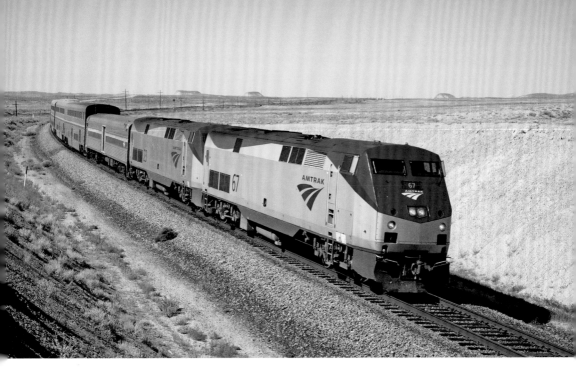

Once the mainline leaves the Colorado River Valley after the Utah border it enters into the empty Utah desert. On 12 September 2008, Amtrak P42 67 and 23, built by GE in 1997 and 1996 respectively, are seen leading the eastbound California Zephyr from Oakland to Chicago near the siding of Cisco, Utah.

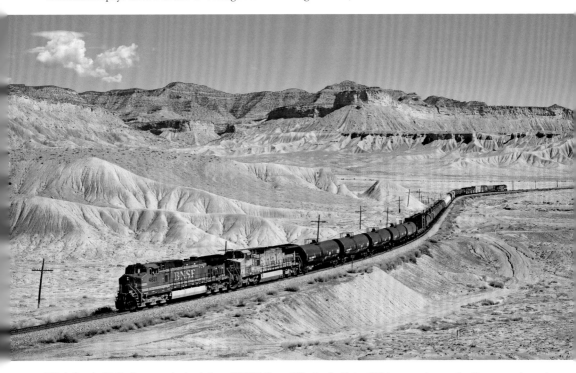

With Book Cliffs forming the backdrop, BNSF C44-9W 4631, built by GE in 2000, is seen leading a westbound BNSF trackage rights train near Thompson Springs, east of Green River, Utah, on 1 September 2007.

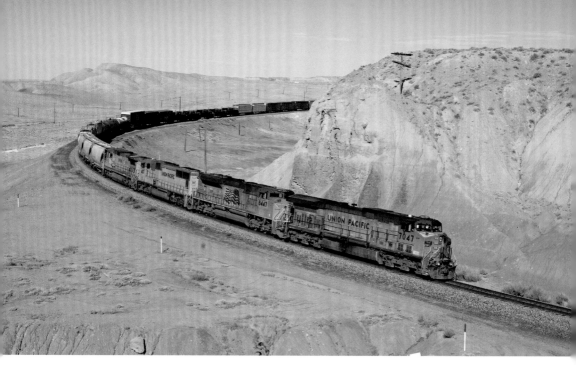

Union Pacific AC4460CW 7047, built by GE in 1995 as a AC6000CW, since downrated, is seen leading an eastbound manifest from Salt Lake City to Denver across the Utah Desert near Thompson Springs, Utah, on 1 September 2007.

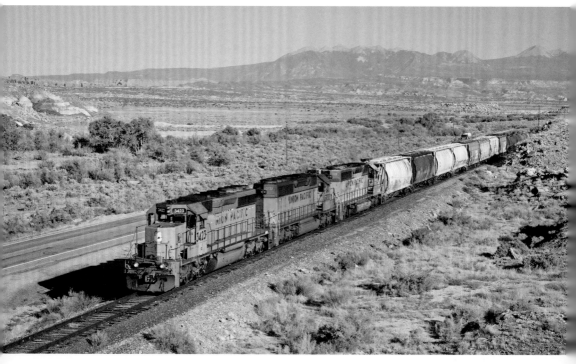

At Brendel, Utah, also known as Crescent Junction, the 35-mile branch to Potash near Moab, Utah, diverges to the south. On 12 September 2008, Union Pacific SD40-2 3423, built by EMD in 1978, and two other SD40-2s are seen leading the weekly local train back from Potash to Grand Junction along the branch between Moab and Brendel.

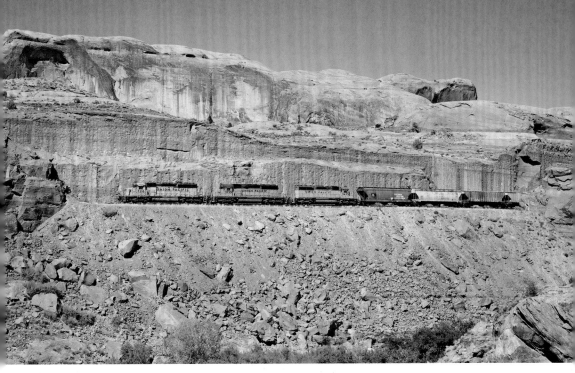

Towards the end of the branch the line enters Bootlegger Tunnel, coming out in Bootlegger Canyon where on 12 September 2008 Union Pacific SD40-2 3216, built by EMD in 1973, is seen leading the weekly local freight from Grand Junction to Potash.

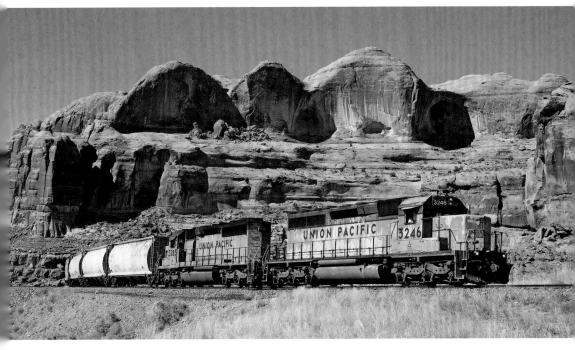

A few miles out of Potash in the Colorado River Canyon, Union Pacific SD40-2 3246, built by EMD in 1974, with SD40-2 3285 are seen leading the returning local from Potash back to Grand Junction about to enter Bootlegger Canyon where the line curves away from the Colorado River on 31 August 2007.

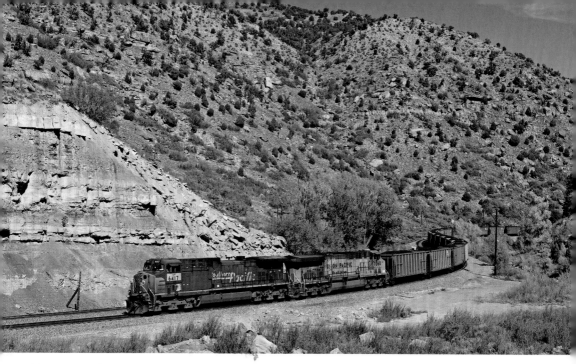

Union Pacific AC4400CW 6417, still in Southern Pacific livery, built by GE in 1995 for the SP, and AC4460CW 7060 are seen leading a loaded coal train up the 2.4 per cent (1 in 41) grade in the Price River Canyon towards Solider Summit west of Helper, Utah, with three helpers in the middle of train and two locos on the rear.

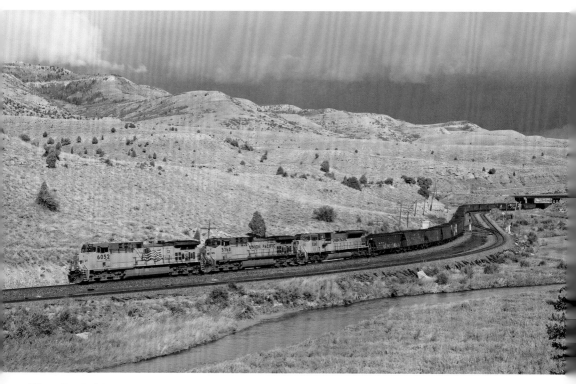

Union Pacific AC4400CW 6052, built by GE in 2003, and AC4400CW 5768 with EMD SD90MAC 8240 are seen leading a loaded coal train from the Helper area up the Soldier Summit grade at Kyune on 10 September 2008.

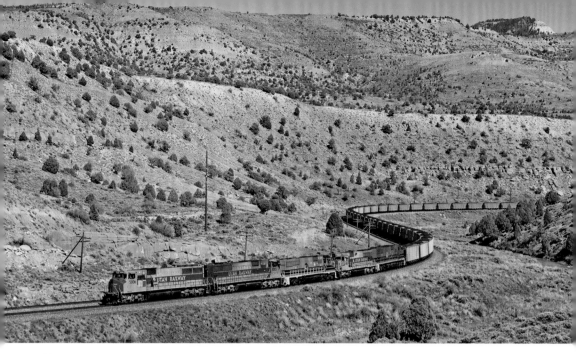

The Utah Railway also has trackage rights over Soldier Summit and until the start of 2017 ran their own unit coal trains from the Helper area to the Salt Lake City area in competition with the Rio Grande and later Union Pacific. On 6 October 2014, Utah Railway MK50-3 5006, built in 1994 as a demonstrator loco by Morrison Knudsen but rebuilt by the Utah Railway to be internally the same as a SD50, is seen leading a Utah Railway coal train upgrade at Kyune with a total of five locos at the front and six helpers in the middle.

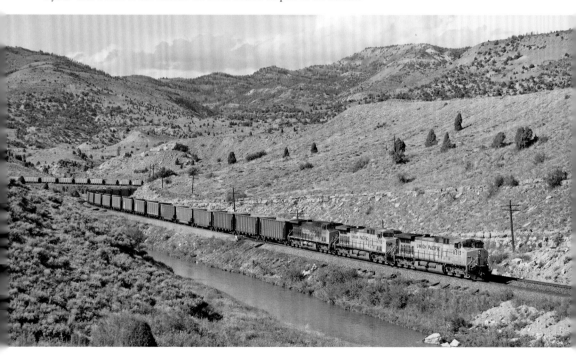

Union Pacific AC4400CW 6515, built by GE in 2000, with AC4400CW 6798 and 6162 still in Southern Pacific livery are seen leading an eastbound empty coal train downgrade at Kyune back to the Helper area for another load on 10 September 2008.

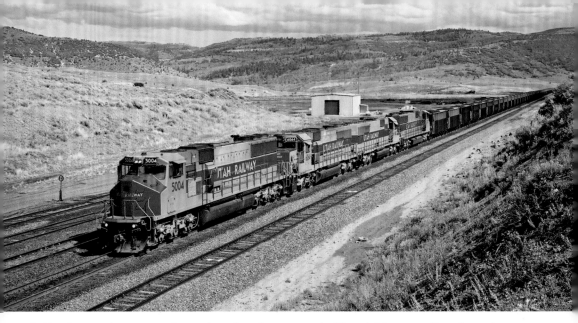

Soldier Summit elevation 7,477 feet is where the railway crosses the Wasatch Mountains. On 11 September 2008, Utah Railway MK50-3 5004, built by Morrison Knudsen in 1994 as a demonstrator loco and rebuilt to be internally the same as a SD50, is seen leading a westbound loaded coal train at the summit. Behind 5004 is Utah Railway 6064 and 6062, both built in 1982 by Clyde Engineering in Australia, hence why they are slightly smaller than a standard American loco.

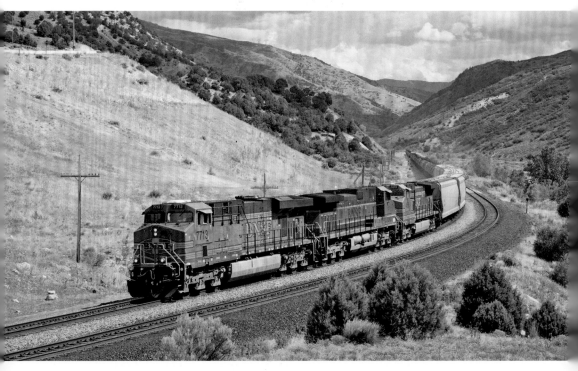

West of Soldier Summit the line descends on a 2 per cent (1 in 50) grade to the bottom of Spanish Fork Canyon. On 10 September 2008, BNSF ES44DC 7713, built by GE in 2005, and two C44-9Ws are seen leading a BNSF trackage rights train from Denver to Provo at Thistle, Utah. The line here was rerouted in 1983 after a mudslide dammed the Spanish Fork River, flooding the original alignment.

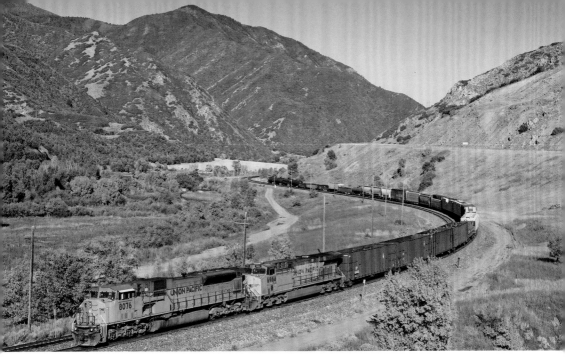

Union Pacific SD9043MAC 8076, built by EMD in 1997, with AC4460CW 6964 are seen leading a short manifest from Salt Lake City to Denver, upgrade in Spanish Fork Canyon on 25 September 2011.

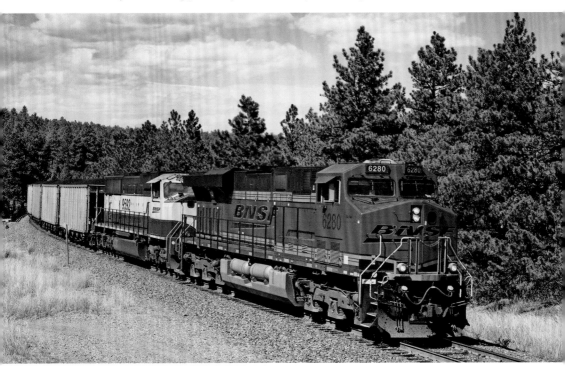

The line south from Denver is known as the Joint Line as both the Rio Grande and Santa Fe (now UP and BNSF respectively) had their own routes and both tracks are now used for directional running. The line crosses the Palmer Divide at an elevation of 7,237 feet. On 19 September 2011, BNSF ES44AC 6280, built by GE in 2008, is seen leading a loaded Powder River coal train south climbing the Palmer Divide at Larkspur, Colorado.

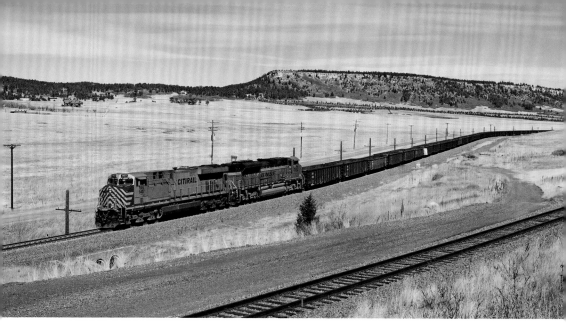

Citirail ES44AC 1407, built by GE in 2014 and on long-term lease to BNSF, is seen with SD70ACe 8585 leading a train of gondolas approaching the summit at Palmer Lake, Colorado, on 9 March 2017.

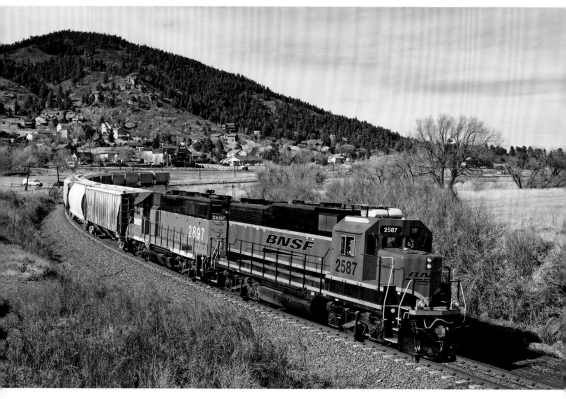

BNSF GP39-3 2587, built by EMD in 1963 for the Santa Fe as a GP30, was later rebuilt into a GP30u before being rebuilt again by BNSF into a GP39-3. It is accompanied by BNSF GP39M 2897 built by EMD in 1964 for the Southern Pacific and rebuilt by the BN into a GP39M. These are seen leading a southbound Denver to Colorado Springs local freight at Palmer Lake, Colorado, on 9 March 2017.

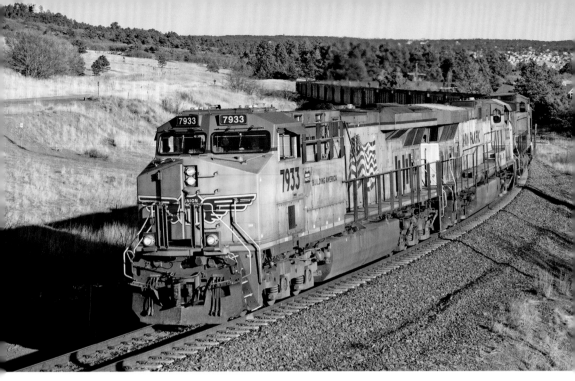

Union Pacific ES44AC 7933, built by GE in 2012, is seen leading a northbound empty coal train from Colorado Springs, climbing up the Palmer Divide on the single track section approaching the summit at Palmer Lake, Colorado, on 8 March 2017.

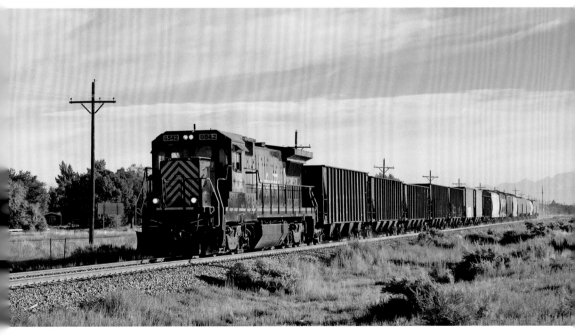

The San Luis and Rio Grande Railroad was formed in 2003 to take over operations of the Union Pacific (formerly Rio Grande) branch lines in the San Luis Valley west of Walsenburg, Colorado. On 27 August 2007, San Luis and Rio Grande B39-8E 8542, built by GE in 1987 as a lease loco for LMX, is seen leading a local freight between Alamosa and Antonito in the San Luis Valley.

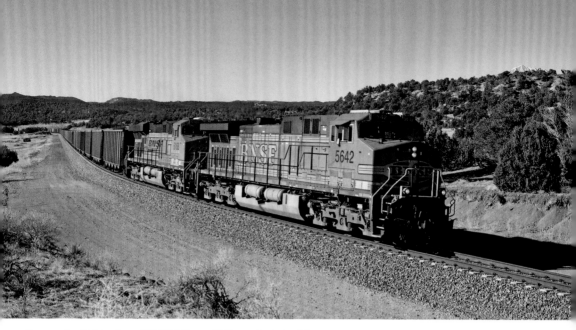

Just south of Walsenburg, BNSF AC4400CW 5642, built by GE in 2003, is seen leading a northbound empty coal train returning from Texas to the Powder River Basin on 8 March 2017. This former Colorado and Southern (now BNSF) line is mainly used for northbound empty trains with loaded southbound trains taking a flatter route to the east.

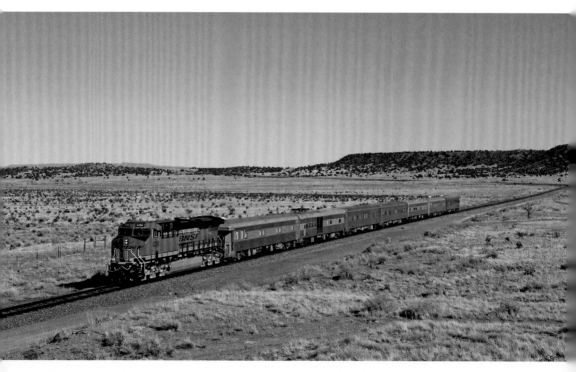

Regular passenger trains on the former Colorado and Southern line from Denver to Texas ended in 1967 when the Texas Zephyr made its final run. However, on 7 March 2017, BNSF ES44C4 4290, built by GE in 2016, is seen leading a northbound business passenger special near the siding of Beshoar south of Trinidad, Colorado.

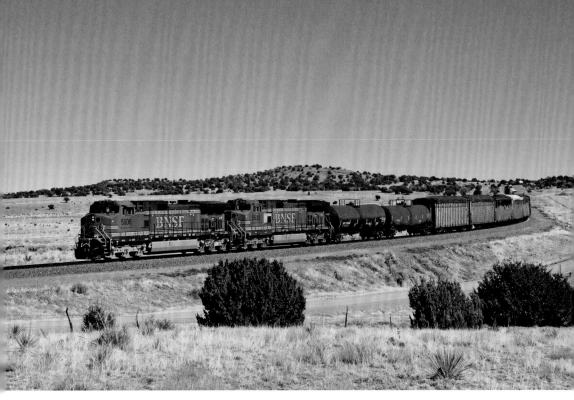

BNSF C44-9W 5006, built by GE in 2004, and C44-9W 5530 are seen leading a northbound manifest near the siding of Barela south of Trinidad, Colorado, on 7 March 2017.

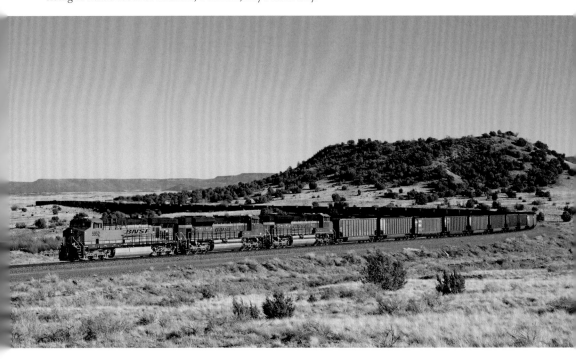

BNSF ES44AC 5952, built by GE in 2006, along with SD70ACe 9084 and 8755 are seen leading an empty northbound coal train from Texas back to the Powder River Basin near the siding of Barela, south of Trinidad, Colorado, on 6 March 2017.

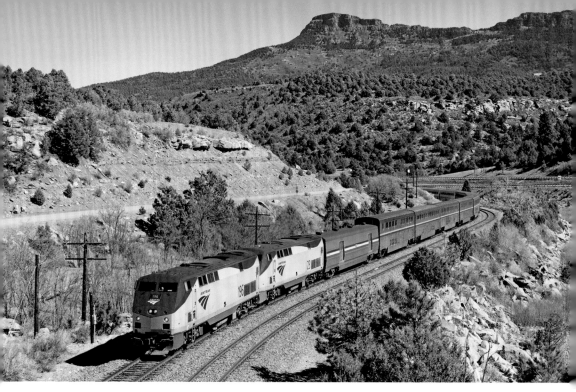

The original Santa Fe mainline over Raton Pass, elevation 7,588 feet, on the Colorado–New Mexico border is now only used by Amtrak with all freight now rerouted to the South. On 6 March 2017, Amtrak P42 196 and 23, built by GE in 2001 and 1996 respectively, are seen leading the westbound Southwest Chief from Chicago to Los Angeles climbing the 3.5 per cent (1 in 28) grade of the Colorado side of Raton Pass.

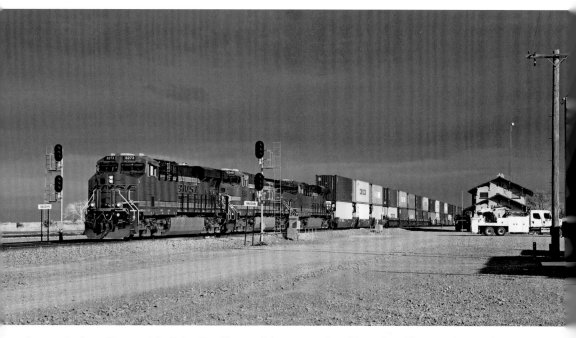

In 1908, the Santa Fe opened the Belen Cutoff to avoid the steep grades of Raton Pass. This runs through Amarillo to west of Belen where it joins up with the existing Raton Pass route. On 5 March 2017, BNSF ES44C4 8273, built by GE in 2014, is seen on the Cutoff leading a westbound double stack train at Vaughn, New Mexico.

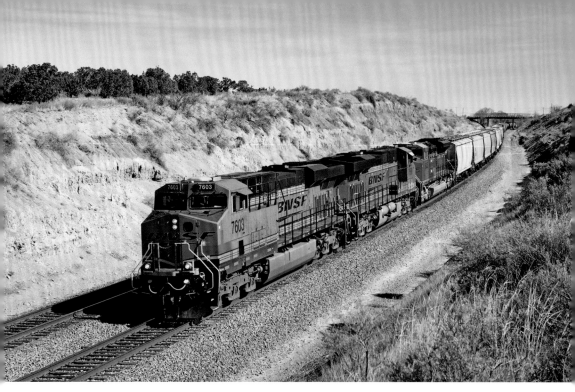

Having passed Mountainair, New Mexico – the highest point on the Belen Cutoff – BNSF ES44DC 7603, built by GE in 2007, is seen leading a westbound manifest beginning the long descent of the 1.25 per cent (1 in 80) Abo Grade to Belen on 4 March 2017.

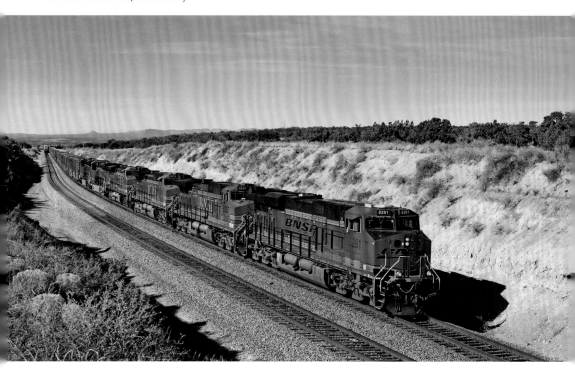

BNSF ES44C4 8261, built by GE in 2014, is seen leading an eastbound manifest nearing the top of the Abo grade approaching Mountainair, New Mexico, on 4 March 2017.

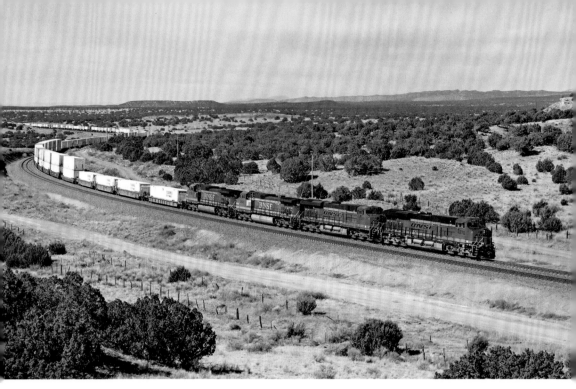

Rounding the 'S bend' below Mountainair, New Mexico, BNSF ES44C4 4270, built by GE in 2016, is seen leading a high-priority Z train climbing up to the summit on 5 March 2017.

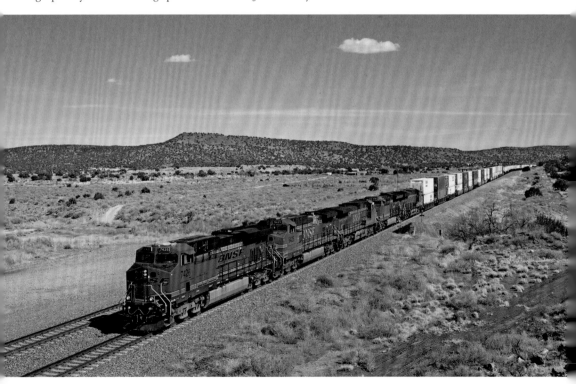

BNSF ES44DC 7426, built by GE in 2008, is seen leading a westbound high-priority Z train on the Abo grade at Scholle on 4 March 2017. At Scholle the line enters the now inaccessible Abo Canyon.

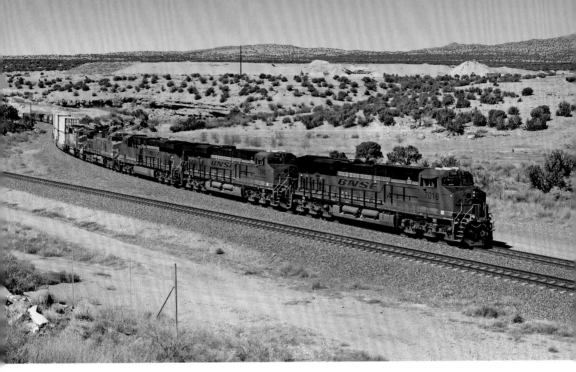

BNSF ES44C4 7018, built by GE in 2013, is seen leading an eastbound double stack train climbing out of Abo Canyon at Scholle, New Mexico, on 4 March 2017. The line in the foreground is now the normal westbound track which was only completed in 2011. Previously the line through Abo Canyon was single track.

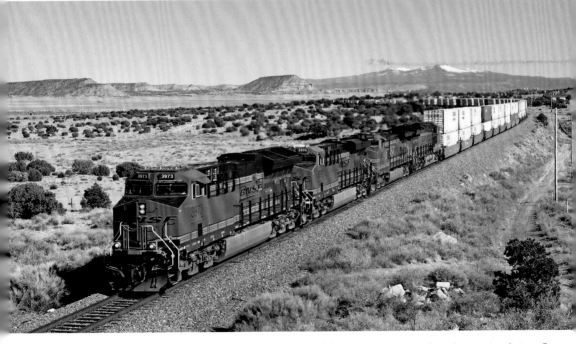

To meet new environmental standards GE launched their Tier 4 emissions compliant locomotive design. On 2 March 2017, one of these locomotives – BNSF ET44C4 3973, built by GE in 2015 – is seen leading a westbound high-priority Z train up to the Continental Divide Summit between Prewitt and Thoreau, New Mexico.

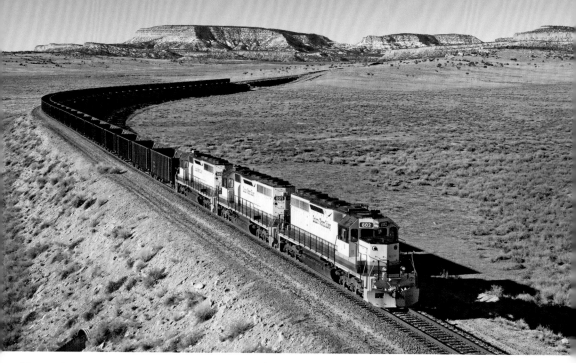

North of Prewitt, New Mexico is a BNSF branch to Lee Ranch and El Segundo coal mines. Just north of the junction at Prewitt is the Plains-Escalante Generating Power Station, which receives coal from these mines moved by the Escalante Western Railroad. On 2 March 2017, SD40-3 602 is seen leading the northbound empty coal train from the power station to El Segundo Mine approaching Lee Ranch Junction.

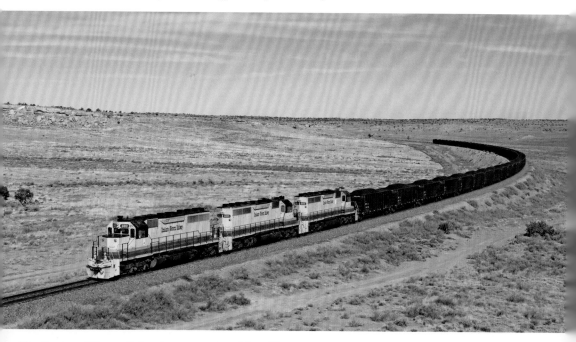

The Escalante Western Railroad roster consists of three SD40-3s, numbered 601-603, which were originally built for the Baltimore and Ohio Railroad by EMD in 1969. These were later purchased second-hand. On 3 March 2017, Western Fuels Association (the holding company for the Escalante Western) 602, 601 and 603 are seen leading a southbound loaded coal from to El Segundo Mine to Prewitt approaching Lee Ranch Junction, New Mexico.

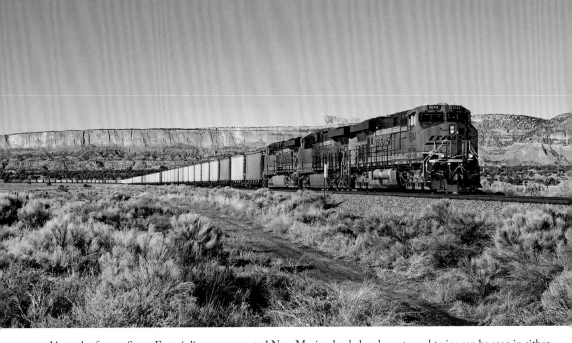

Along the former Santa Fe mainline across central New Mexico, loaded and empty coal trains can be seen in either direction. On 2 March 2017, BNSF ES44AC 6044, built by GE in 2006, is seen leading an eastbound loaded coal train up to the Continental Divide Summit near Coolidge with two DPU locos just visible on the rear.

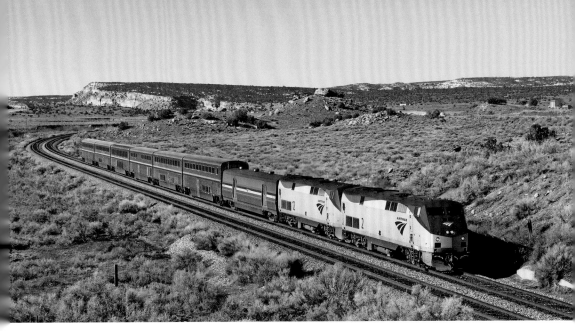

Amtrak P42 2 and 12, both built by GE in 1996, are seen leading the eastbound Southwest Chief from Los Angeles to Chicago at Defiance, New Mexico, on 1 March 2017.

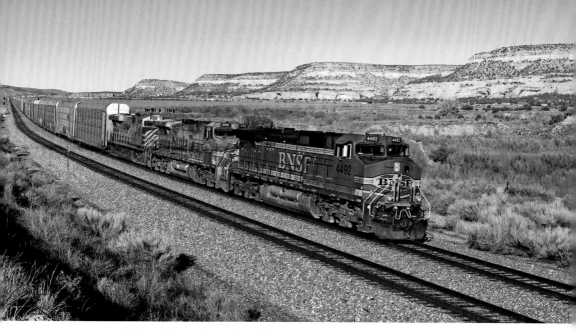

BNSF C44-9W 4492, built by GE in 1999, with a tired-looking BNSF 696 still in Santa Fe livery, built by GE in 1994, and a Citirail lease loco ES44AC 1212 are seen leading a westbound autorack train at Lupton, New Mexico, approaching the New Mexico–Arizona border on 1 March 2017.

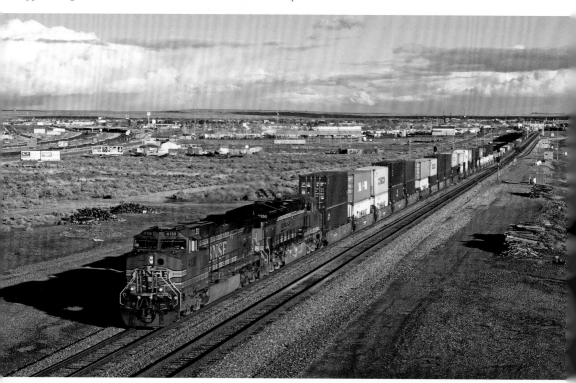

BNSF C44-9W 4138, built by GE in 2002,, with a much newer ET44C4 3856, built by GE in 2015, are seen leading a westbound double stack train out of Winslow, Arizona, on 28 February 2017 with two more locos working as DPU on the rear.

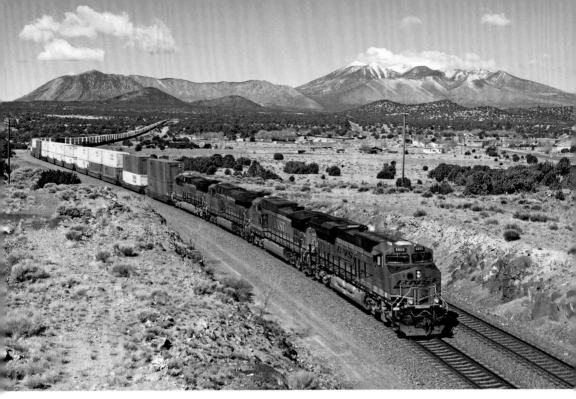

BNSF ES44DC 6955 built by GE in 2012 is seen leading an eastbound high-priority Z train at Winona around 15 miles east of Flagstaff, Arizona, with the snow covered San Francisco Peaks in the background on 8 March 2014.

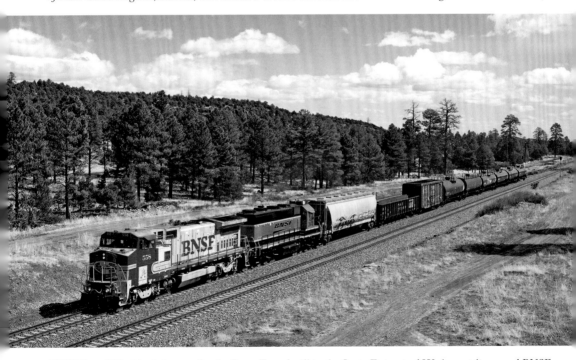

BNSF B40-8W 558 built in 1990 for the Santa Fe and still in the Santa Fe inspired Warbonnet livery and BNSF GP39-3 2670, built in 1965 as a GP35 and later rebuilt into a GP39-3, are seen leading a Winslow to Flagstaff local freight approaching Flagstaff on 7 March 2014.

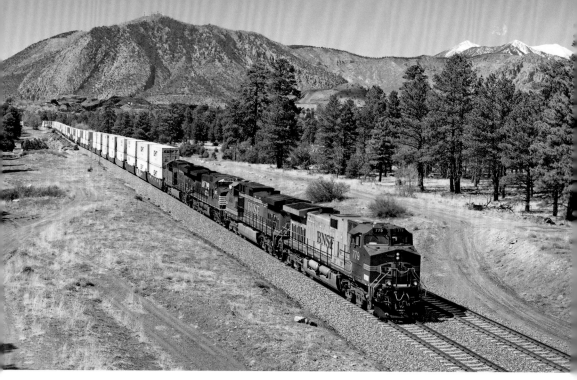

BNSF C44-9W 779, built by GE in 1997, still in the Santa Fe-inspired Warbonnet livery but delivered after the BNSF merger, is seen leading an eastbound high-priority Z train at East Flagstaff on 7 March 2014.

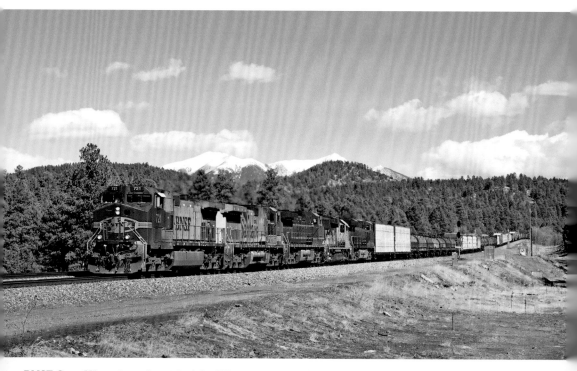

BNSF C44-9W 721, 671 and 1036, built by GE in 1997, 1994 and 1996 respectively, are seen leading a westbound manifest from Belen to Barstow at Maine, Arizona, descending from the Arizona Divide on 7 March 2014. Each of the five locos on the front are all in different liveries with 671 still in full Santa Fe Warbonnet livery.

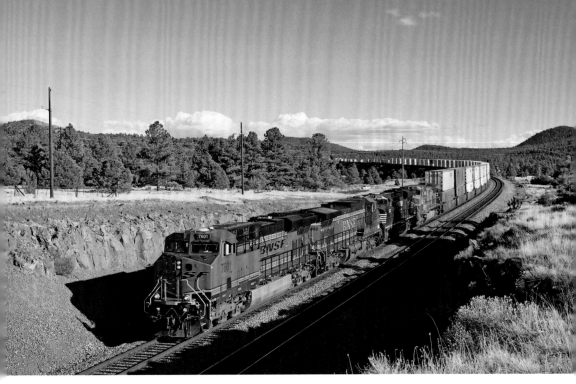

BNSF ES44DC 7601, built by GE in 2007, is seen leading a westbound high-priority Z train north of Williams, Arizona, on 7 March 2014. This section of track between Williams and Seligman was opened in 1960 to replace the original line, with steep grades via Ash Fork.

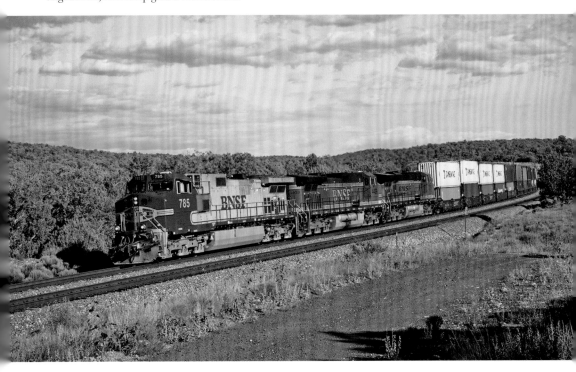

BNSF C44-9W 785, built by GE in 1997 and still in its original Warbonnet livery, is seen leading a westbound double stack at Double A between Williams and Seligman on 23 July 2008.

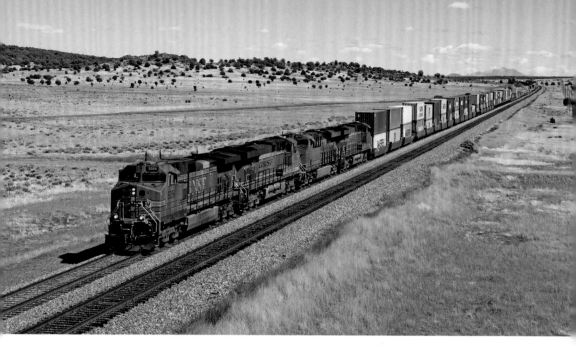

BNSF C44-9W 5086, built by GE in 2004, is seen leading a westbound double stack train about to pass under the historic Route 66 highway bridge at Crookton, Arizona, on 8 March 2014.

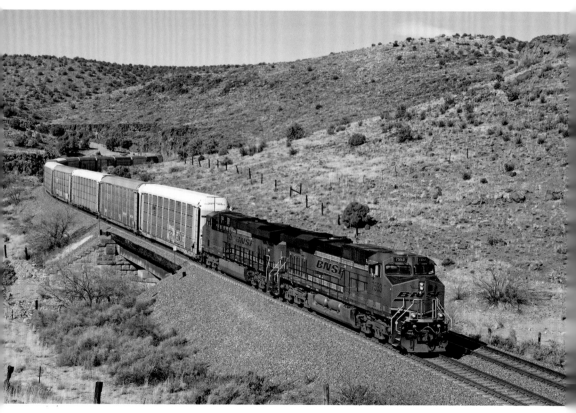

BNSF ES44DC 7553, built by GE in 2007, is seen leading an eastbound autorack train leaving Crozier Canyon at Truxton, Arizona, on 10 March 2014.

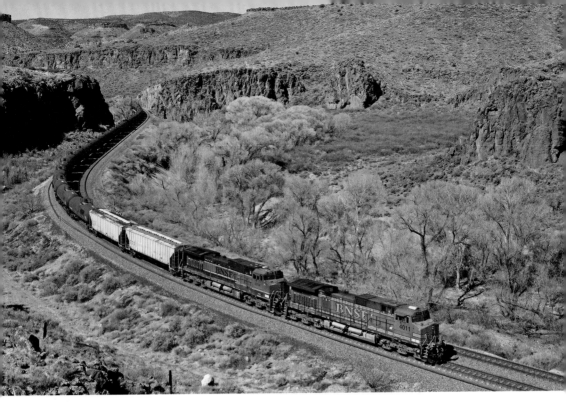

BNSF C44-9W 4011, built by GE in 2003, is seen leading an eastbound unit tank car train climbing through Crozier Canyon between Valentine and Truxton, Arizona, on 10 March 2014.

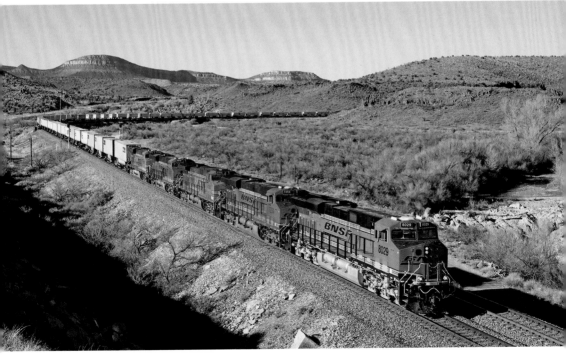

A new looking BNSF ES44C4 8029, built by GE in 2014, is seen leading a westbound high-priority Z train exiting Crozier Canyon at Valentine, Arizona, on 8 March 2014.

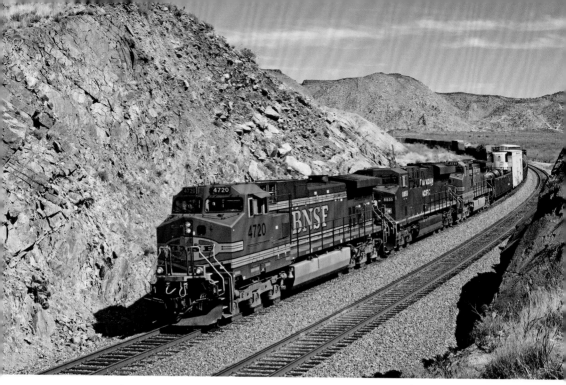

BNSF C44-9W 4720, built by GE in 1997, with Canadian Pacific ES44AC 8855 and BNSF C44-9W 4744 are seen leading a westbound manifest at Hackberry east of Kingman, Arizona, on 9 March 2014.

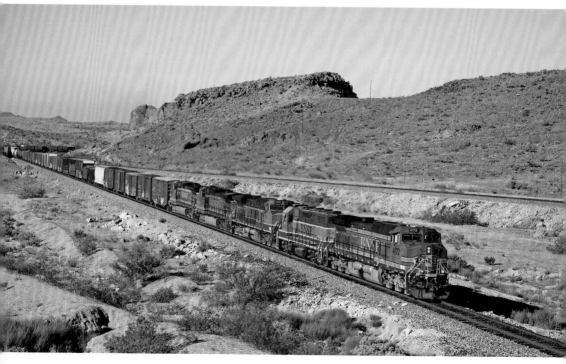

BNSF C44-9W 4172, built by GE in 2002, is seen leading an eastbound manifest through Kingman, Arizona, at Getz on 29 July 2008. The second loco is BNSF 2590, a GP35u built by EMD for the Santa Fe in 1965 as a GP35 and later rebuilt to a GP35u.

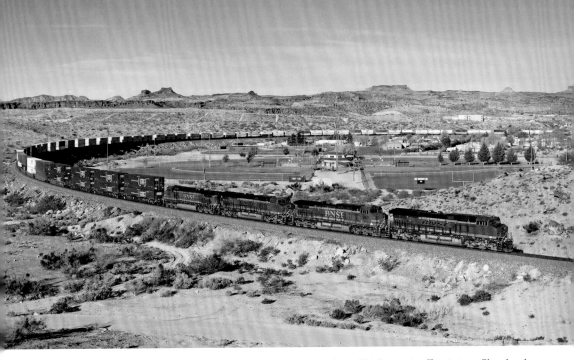

BNSF ES44C4 6713, built by GE in 2011, is seen leading an eastbound high-priority Z train into Slaughterhouse Canyon just south of Kingman, Arizona, on 9 March 2014. The westbound track here is on a different alignment.

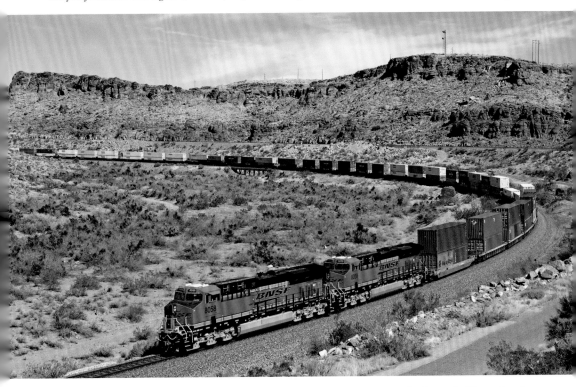

On their first trip west since delivery to BNSF, ES44C4 8058 and 8059 are seen leading a double stack train west in Kingman Canyon west of Kingman, Arizona, on 9 March 2014. Working as DPU locos on the rear were also brand-new ES44C4 8060 and 8063.

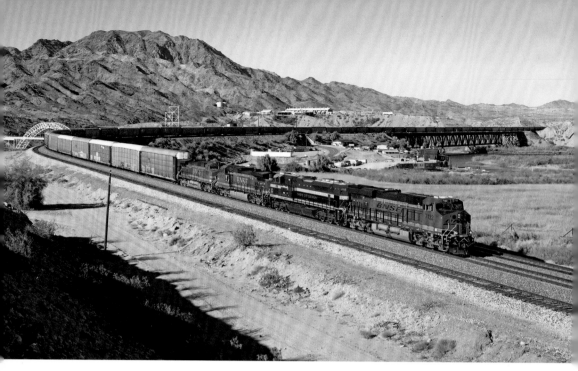

BNSF ES44C4 7132, built by GE in 2013, with Kansas City Southern SD70ACe 4158 and two BNSF C44-9W – 4747 and 4577 – are seen leading an eastbound autorack train over the Colorado River crossing from California into Arizona at Topock on 12 March 2014.

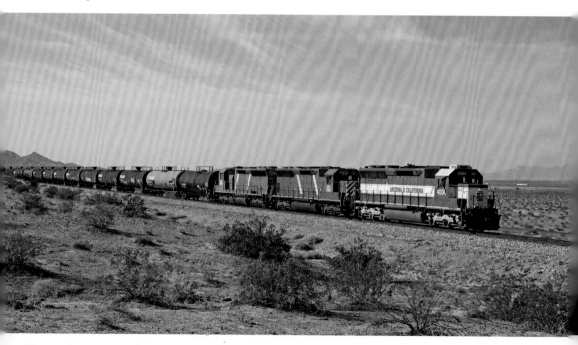

Phoenix, Arizona is around 130 miles south of the BNSF mainline. It is served from the east by a BNSF branch from Williams. The line to the west is now owned by the Arizona and California Railroad which rejoins the main BNSF line at Cadiz, California. On 11 March 2014, Arizona and California SD40-2M 4004, built in 1966 for the Southern Pacific and later rebuilt into a SD40-2M and sold to the Arizona and California, is seen working the daily westbound freight on the line approaching Parker, Arizona.

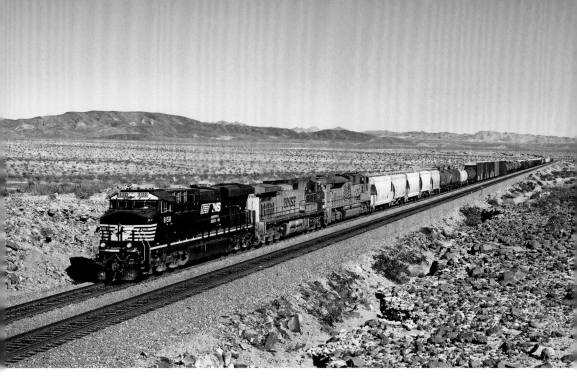

Norfolk Southern ES44AC 8158, built by GE in 2013, as well as BNSF C44-9W 746 and Union Pacific SD70ACe 8781 are seen leading a westbound manifest climbing Ash Hill in California's Mojave Desert on 19 March 2014.

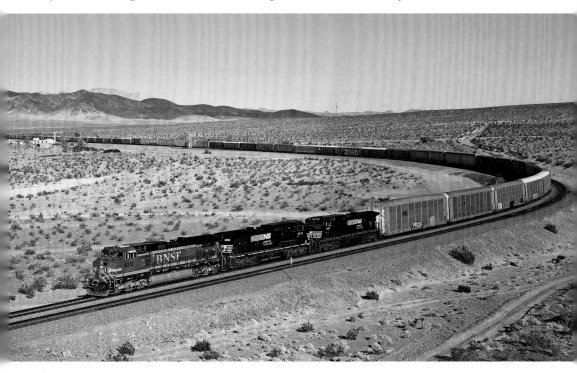

BNSF C44-9W 5312, built by GE in 2001, along with Norfolk Southern C40-8W 8426, built by GE in 1994 for Conrail, and C40-9W 9307 are seen leading a westbound autorack train across California's Mojave Desert at Ludlow on 12 March 2014.

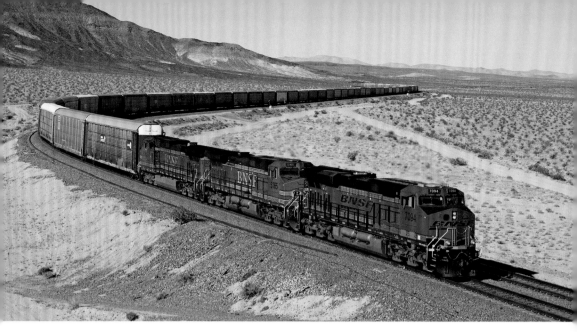

BNSF ES44C4 7094, built by GE in 2012, and C44-9W 5165 and 5162 are seen leading an eastbound autorack train across the Mojave Desert at Ludlow, California, on 19 March 2014.

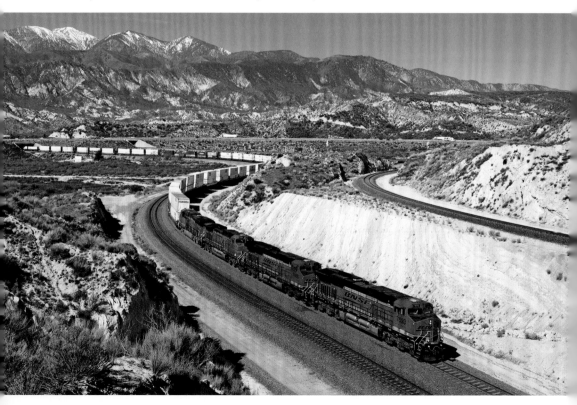

In order to enter the Los Angeles Basin the line crosses Cajon Pass. On 18 March 2014, BNSF ES44DC 7593, built by GE in 2007, is seen leading an eastbound high-priority Z train climbing up the 2.2 per cent (1 in 45) grade of Cajon Pass at Alray between San Bernardino and Victorville, California. The snow-covered San Gabriel Mountains provide the backdrop.

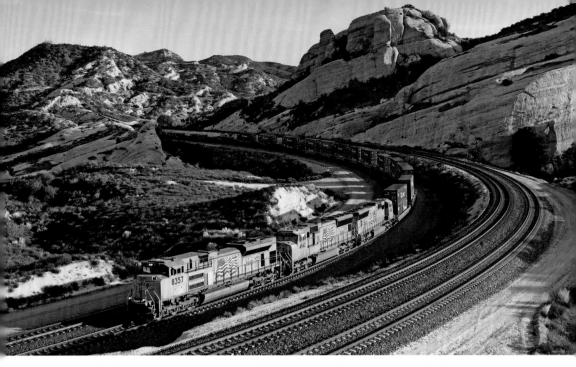

Union Pacific SD70ACe 8357, built in 2005 by EMD, is seen leading an eastbound double stack train rounding Sullivan's Curve on the climb up Cajon on 17 March 2014. The train here is seen on the BNSF track, on which the Union Pacific has trackage rights, in addition the line in the foreground is the former Southern Pacific Palmdale Cutoff, which is also now owned by the Union Pacific.

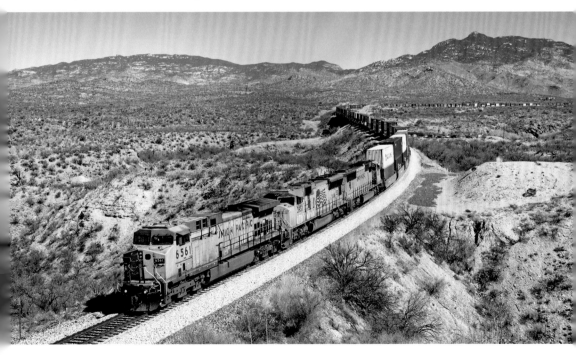

Union Pacific AC4400CW 6561, built by GE in 1997, with two SD70M – 3957 and 4265 – are seen leading a westbound double stack train at Cienega Creek near Vail, Arizona, on 25 February 2017. This line is the former Southern Pacific's Sunset route to New Orleans from California.

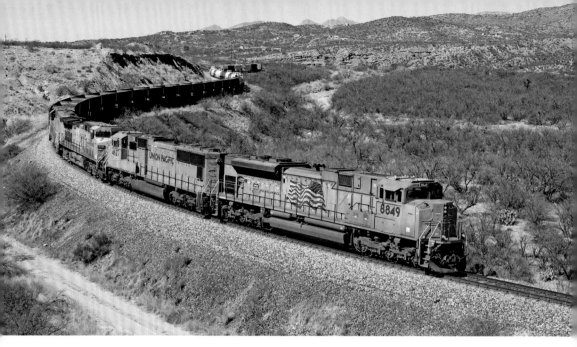

Union Pacific SD70ACe 8849, built by EMD in 2014, with SD70M 4627, AC4400CW 6746 and a GP38-2 are seen leading an eastbound manifest climbing upgrade at Cienega Creek, Arizona, on 25 February 2017.

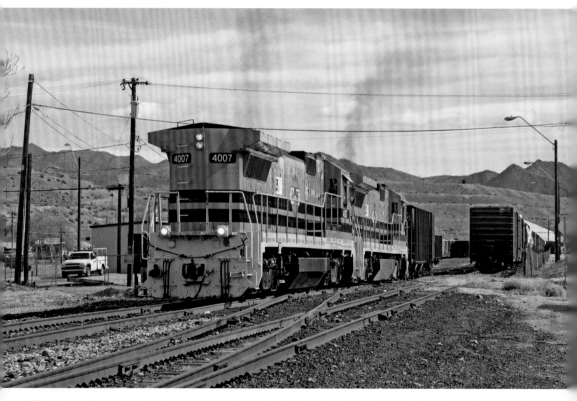

The Arizona Eastern Railroad operates some former Southern Pacific branch lines in South Eastern Arizona. On 27 February 2017, B40-8 4007, built by GE in 1987, and B40-8 4011, both for the Southern Pacific, are seen leaving Miami, Arizona, heading for the nearby copper mine. The locos are running long hood forward.

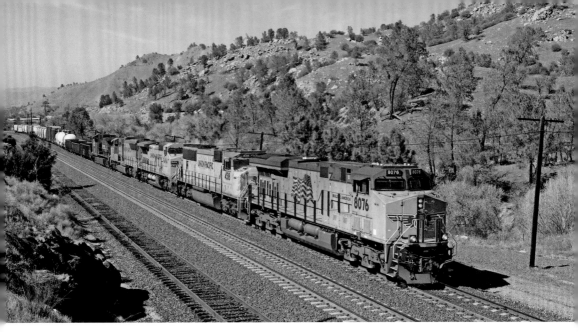

Union Pacific ES44AC 8076, built by GE in 2013, is seen leading a short southbound manifest at Woodford climbing Tehachapi Pass on 16 September 2014. The line over Tehachapi Pass between Bakersfield and Mojave, California, was built by the Southern Pacific and the Santa Fe was given trackage rights.

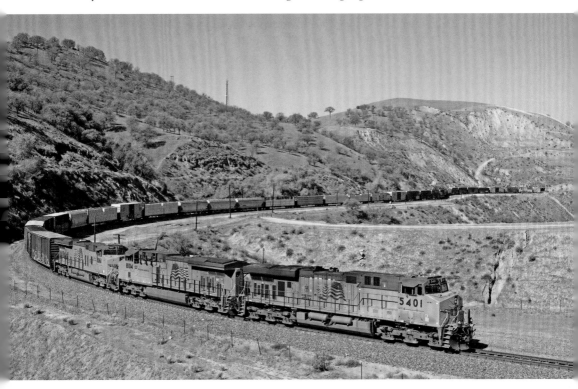

Union Pacific ES44AC 5401, built by GE in 2005, with ES44AC 8104 and 8061 are seen leading a southbound manifest from Roseville to West Colton upgrade near Bealville, California, on 16 March 2014. The line over Tehachapi Pass reaches the summit at 3,771 feet and is the main freight route from the Los Angeles area to the San Francisco Bay Area.

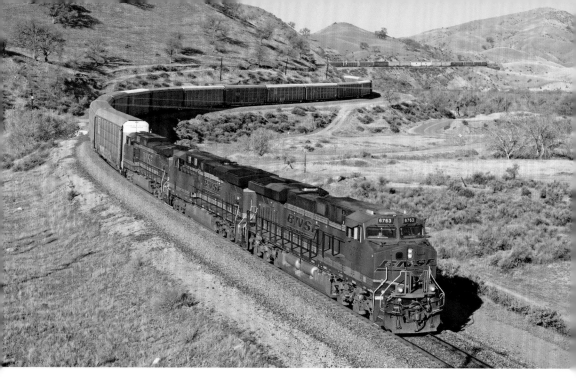

BNSF ES44C4 6763, built by GE in 2011, with ES44DC 7496 and C44-9W 5076 are seen leading a northbound autorack train at Caliente, California, descending from Tehachapi on 16 March 2014.

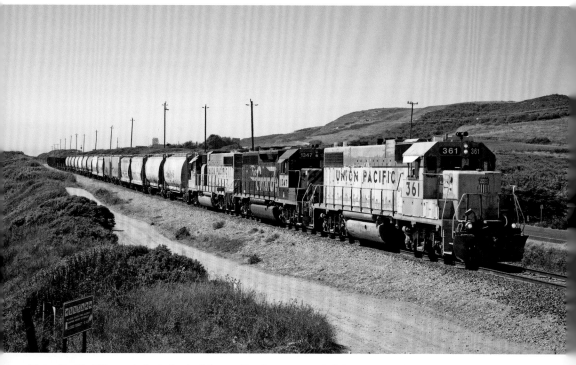

Union Pacific GP38-2 361, built for the Missouri Pacific in 1973, with GP40-2 1347, built for the Rio Grande in 1972 and still in Rio Grande livery, and GP38-2 791, built for the Missouri Pacific, are seen leading a southbound local freight from Davenport to Watsonville Junction on a former Southern Pacific branch line on 4 August 2008.

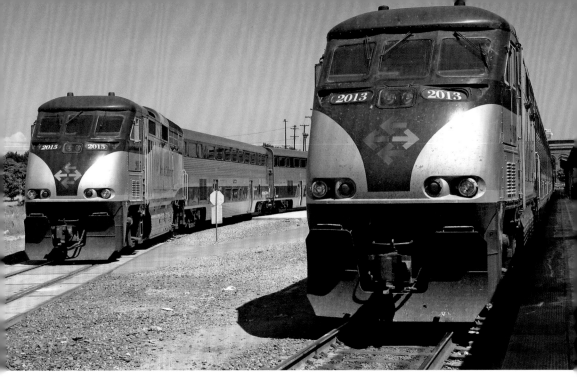

As well as Amtrak-operated long-distance passenger trains, Amtrak also operates regional trains within the state as 'Amtrak California'. On 4 July 2005, F59PHi 2015 and 2013, both built by EMD in 2003, are seen at the station in Sacramento, California, awaiting their next duty.

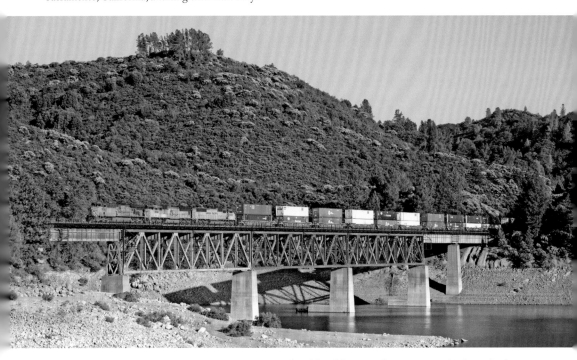

Union Pacific ES44AC 5385, built by GE in 2005, as well as SD70M 5024 and 3989 are seen leading a high-priority Z train over Lake Shasta at Lakehead, California on 30 September 2011. This is on the former Southern Pacific line from Sacramento to Portland, Oregon, and is now the Union Pacific north–south line on the West Coast.

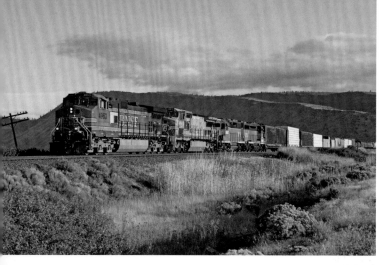

BNSF C44-9W 4963, built by GE in 1998, is seen leading a southbound manifest near Klamath Falls, Oregon, on 2 October 2011. Behind the lead loco are C40-8W 881 still in Santa Fe livery and BNSF GP28M 1519, which was built as a GP9 in 1959 for the Great Northern and later rebuilt as a GP28M, and GP39M 2824, which was built for the Burlington in 1963 and later rebuilt into a GP39M.

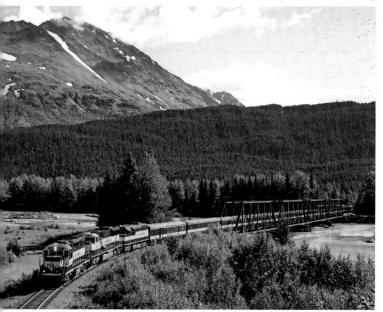

The Alaska Railroad is isolated from the rest of the North American rail system apart from by rail barge. The line runs from Seward through Anchorage to Fairbanks. On 23 July 2010, Alaska Railroad 2001, which was built by EMD in 1977 for the Butte Anaconda & Pacific and later sold to the Alaska Railroad, is seen leading the Anchorage to Seward passenger train crossing the Snow River on the approach to Seward. Behind the lead loco are SD70MAC 4322 and 32. 32 is a former Amtrak F40PH that now only provides an electric supply to the train.

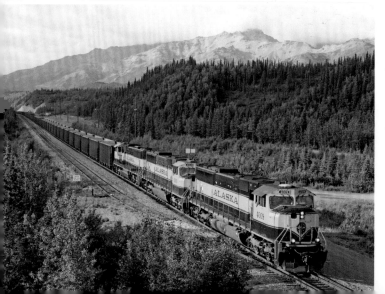

Alaska Railroad SD70M 4009, 4003 and 4007, built by EMD in 2000, 1999 and 2000 respectively, are seen leading an empty coal train at Healy on 28 July 2010. The coal train will be loaded at the Usibelli loadout just north of Healy before returning to the Port of Seward where the coal will be unloaded for export.